Robert Arneson: Self-Reflections

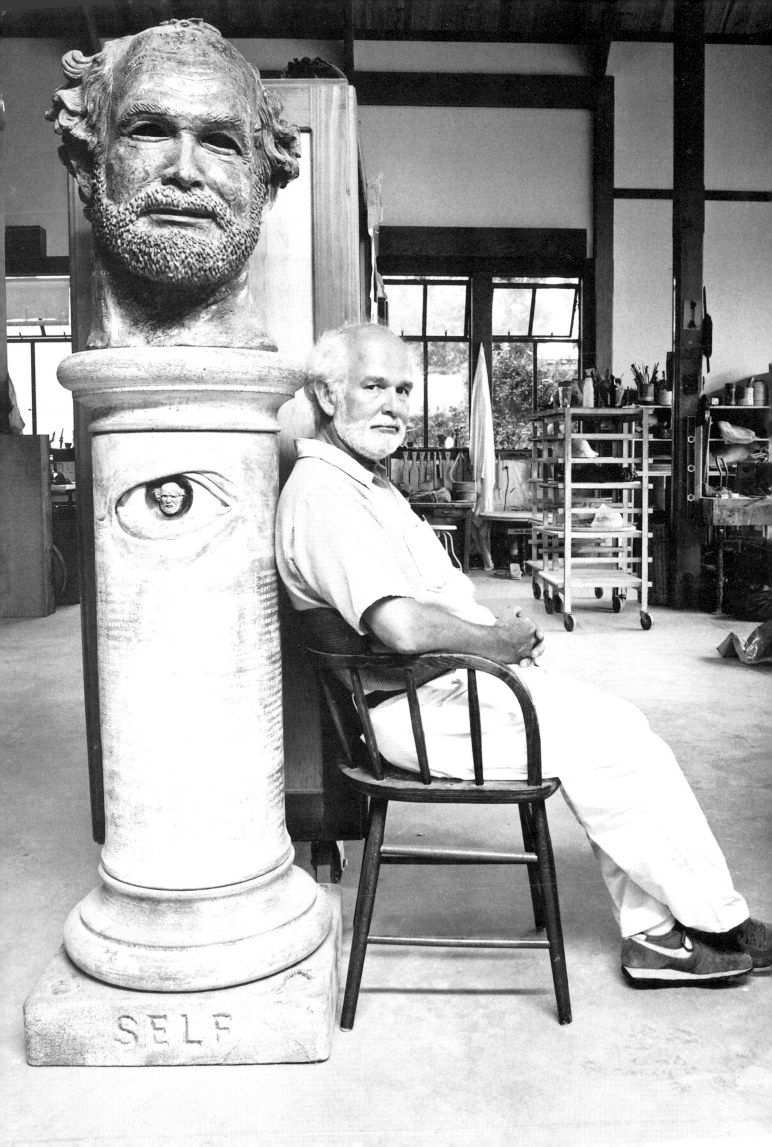

Robert Arneson: Self-Reflections

Exhibition organized by Gary Garrels and Janet Bishop

Essay by Jonathan Fineberg

San Francisco Museum of Modern Art

This catalogue is published on the occasion of the exhibition *Robert Arneson: Self-Reflections*, organized by Gary Garrels and Janet Bishop at the San Francisco Museum of Modern Art. On view February 14 to May 13, 1997.

Generous support for *Robert Arneson: Self-Reflections* has been provided by Judy and John Webb; Jean and Jim Douglas; Toni and Arthur Rock; Mr. and Mrs. Brooks Walker, Jr.; and Pat and Bill Wilson.

Library of Congress Cataloging-in-Publication Data

Garrels, Gary
 Robert Arneson : self-reflections / Janet Bishop, Gary Garrels, and Jonathan Fineberg.
 p. cm.
 Published on the occasion of the exhibition at the San Francisco Museum of Modern Art, Feb. 14 to May 13, 1997.
 ISBN 0-918471-39-7
 1. Arneson, Robert, 1930–1992—Self-portraits—Exhibitions. 2. Ceramic sculpture—United States—Exhibitions. I. Bishop, Janet C. II. Fineberg, Jonathan David. III. San Francisco Museum of Modern Art. IV. Title.
 NK4210.A69A4 1997
 730' .92—dc21 96-51834
 CIP

Publications Manager: Kara Kirk
Editor: Fronia Simpson
Editorial Assistant: Alexandra Chappell
Designer: Terril Neely

Photo Credits:
Frontispiece: Kurt Fischback. Figure 1: M. Lee Fatherree; fig. 2: Paul Macapia; fig. 3: M. Lee Fatherree; fig. 4: Phillip Galgiani; fig. 5: Des Moines Art Center; fig. 6: Susan Einstein. Plate 1: Eva Heyd; pl. 2: M. Lee Fatherree; pl. 3: George Adams Gallery; pl. 8: M. Lee Fatherree; pl. 9: Leo Holub; pls. 10, 11: M. Lee Fatherree; pl. 12: Schopplein Studio, San Francisco; pls. 13, 14, 16: Ben Blackwell; pls. 17, 18: M. Lee Fatherree; pl. 19: Alo Zanetta; pls. 20–52: M. Lee Fatherree; page 79: Abe Frajnlich.

Cover: *Captain Ace*, 1978 (detail of pl. 5); Collection of the Stedelijk Museum, Amsterdam

Frontispiece: Robert Arneson in his studio sitting against *This Head Is Mine* (pl. 10), 1985

Printed and bound in Hong Kong

Director's Foreword

JOHN R. LANE

Robert Arneson (1930–1992) is one of the defining personalities of late-twentieth-century artistic culture in the San Francisco Bay Area. His irreverence toward convention, raucous good humor, experimental spirit, and deeply felt political and social convictions made him a leader on a scene that took pride in conspicuous non-conformance with the wider art world. Both as a person of generous and vigorous presence and as an artist who created some of the most memorable and compelling images to be invented by a Northern Californian, he was and remains a treasure in the region and a force in recent American art. It is a special privilege and honor for SFMOMA to present this exhibition of his self-portraits, a genre in which Arneson's accomplishments are unsurpassed by his contemporaries and a form in which he achieved his most penetrating insights as a sculptor and a humanist.

Jonathan Fineberg, professor of the history of art at the University of Illinois at Urbana-Champaign, who at an early point shared with us his admiration and knowledge of the work of Robert Arneson, graciously agreed to write the essay for this catalogue, extending to the public the evidence of his research and his insights; we thank him for working closely with us under a very tight schedule.

Arneson's sculptures are both beloved and fragile, and we are extremely grateful to the lenders to the exhibition, who are listed individually on page eight of this publication, for entrusting these works to our care and for sharing them with the visitors to the exhibition.

At SFMOMA, Gary Garrels, Elise S. Haas chief curator and curator of painting and sculpture, conceived and organized this project, in partnership with Janet Bishop, Andrew W. Mellon Foundation assistant curator of painting and sculpture. We heartily thank them both for their contributions. We also appreciate the staff members who have particularly helped realize this exhibition: Suzanne Feld, curatorial assistant; Lori Fogarty, director of curatorial affairs; Jeremy Fong, assistant registrar/exhibitions; Tina Garfinkel, head registrar; Barbara Levine, exhibitions manager; Kent Roberts, installation manager; Will Shank, chief conservator; Marcelene Trujillo, exhibitions assistant; and Heather Lind, secretary, department of painting and sculpture.

This publication is also the result of the work of a number of individuals deserving acknowledgment, including SFMOMA staff members Kara Kirk, publications manager; Alexandra Chappell, publications assistant; and Terril Neely, design assistant. Thanks are also due to Fronia W. Simpson, who brought her editorial expertise to bear on the text. Patricia Thomas, assistant to Sandra Shannonhouse, provided invaluable assistance at many stages in the organization of the exhibition and production of the catalogue.

Generous support for this exhibition has been provided by Judy and John Webb; Jean and Jim Douglas; Toni and Arthur Rock; Mr. and Mrs. Brooks Walker, Jr.; and Pat and Bill Wilson. We gratefully acknowledge their beneficence.

And finally, our deepest thanks go to Sandra Shannonhouse who, as an artist in her own right and as the companion and wife of Robert Arneson over two decades, gave us keen insights into the work and generous and unfailing assistance and encouragement in mounting this exhibition.

Lenders to the Exhibition

American Craft Museum, New York

Harry W. and Mary Margaret Anderson

Birmingham Museum of Art, Alabama

Buchbinder Family Collection

Des Moines Art Center

Estate of Robert Arneson

Dede and Oscar Feldman

Daniel Fendrick Family Collection

Stanley and Gail Hollander

Mr. and Mrs. A. J. Krisik

Arthur J. Levin

Private Collections

Philip Rolla

San Francisco Museum of Modern Art

Sandra Shannonhouse

Russ Solomon and Elizabeth Galindo

Stedelijk Museum, Amsterdam

Ross and Paula Turk

Preface
G A R Y G A R R E L S

Soon after arriving in San Francisco in the fall of 1993 to begin work at the San Francisco Museum of Modern Art, I journeyed to Benicia to see the studio of Robert Arneson and to talk with Sandra Shannonhouse, his widow. Arneson had died the year before, after struggling with cancer for nearly two decades. Thanks to a warm introduction from Jonathan Fineberg, an old friend of both Arneson and Shannonhouse, Sandy welcomed my queries with generous accommodation and opened Arneson's studio to me, including his private work space, in which hung a large, unfinished self-portrait on paper (pl. 31). She also took me to separate storage rooms to look at some of Arneson's final works, including two sculptures Arneson had completed in his last year, *Chemo 1* and *Chemo 2*, which had not been exhibited and were not generally known. They were haunting, tough images that I could not get out of my mind, and sometime later I asked to see them again. Their formal complexity and layered references triggered for me a searching reassessment of Arneson's entire body of work and particularly his self-portraiture.

Now three years later, after continuing to rethink the work of Robert Arneson, it has become ever more clear to me that far beyond the marvelous humor and irony, which are so readily apparent and recognized, the ballast of his work is no less a brooding, open-eyed stare at the existentialist condition of the human situation—an array of psychological and physical frailties from which no individual is immune—and acknowledgment that death is the one subject none of us can ultimately avoid. As one of Arneson's great obsessions, self-portraiture reveals the coherence and the tension of his work. In his portrayal of self, Arneson often reached his most playful and inventive forms while opening up the starkest appraisal of his subject. In his expression and in our response, laughter is mixed with anguish, mockery with anger, and pride with vulnerability. This exhibition is a selective and focused overview of his self-portraits, the earliest from 1965 and the last from 1992. In organizing this presentation, our goal has been to encourage a richer reading of Arneson's work at every stage and to set out clearly the trajectory by which the last self-portraits were reached, to understand them not as isolated works but as ones deeply embedded in a career of unflinching self-reflection.

Robert Arneson's work remains singular in the art of our time, for it is resistant to being placed in an available niche of art history. It is my sincere hope that this exhibition will make clearer the importance of his achievement, not only as an iconoclast, but as a profound assessor of the human condition and of the potential and meanings of art.

Humor at the Frontier of the Self
JONATHAN FINEBERG

"Cant make serious ART anyway," Robert Arneson scribbled with a puckish irony across a questionnaire for a survey book on California artists at the beginning of the eighties.[1] Yet this really *is* the secret anxiety of every artist who goes beyond the perimeters of accepted practice. Is it art at all? Like Jackson Pollock, Arneson was compelled to try the new in search of explanations to the pressing, unanswered questions of experience and reflection. The need to see "what it will look like" overcomes all else for the artist because it opens a fresh, symbolic perspective on reality—a spiritual necessity that is life sustaining. What creature in nature survives without an ongoing accommodation to the perpetually changing facts of existence?

In the urgency of this pursuit, both Pollock and Arneson seemed aggressively self-confident, willing to risk anything. Yet the moment either one of these artists stepped outside their work, self-doubt began spreading like a dark cloud of smoke. Pollock was tormented by it. Lee Krasner reported that one time he even asked her, "in front of a very good painting…, 'Is this a painting?' Not is this a good painting, or a bad one, but a *painting!* The degree of doubt was unbelievable at times," she recalled. "And then, again, at other times he knew the painter he was."[2] Pollock's vaunted belligerence was an expression of this uncertainty.

Arneson identified with Pollock's tragic doubt but veiled his own doubt in sarcasm, directed chiefly at himself. "I weigh 182 lbs I'm 5'8" tall I wear hearing aids in each ear," Arneson wrote in red ink up the margin of that same questionnaire, "strain to hear but seldom understand significant issues, causing acute paranoia & irritableness. Liquor helps—clay recommended for therapy."

By 1959 Arneson fully understood the introspective achievement of the New York school and had begun gauging himself against that standard of "significant" content. His defiant sarcasm in response to this questionnaire reveals the perseverance of an anxiety about measuring up. In these remarks, and much more publicly in his sculpture and drawings, Arneson, in effect, boisterously shouted adolescent catcalls in the mirror as a form of dialogue with himself to probe the areas of his own greatest discomfort (and most profound inquiry). Often he even scratched graffiti across his work, as though conversing about it as it evolved. Self-exposure in the public pillory is an Arneson trademark.

The deliberately ungainly pottery that Arneson made at the end of the 1950s, as he emerged from the cocoon of a "ceramics teacher" into a "funk" sculptor, already evidenced his characteristic, sardonic self-mockery. His funk pots and objects (fig. 1) derive their power in large measure from their imaginative transgression of the standards of decorum in the craft; the nature and extent of this transgression are exactly parallel to the difference between Arneson's perspective on events and the prevailing views of his times. From the outset, his work pushed the boundaries of good taste, of "high" art, of acceptable technique and style to examine what is repressed by such rules—both in culture and in his own psyche.

"I want to make 'high' art that is outrageous," he wrote, "while revealing the human condition which is not always so high."[3] It was *himself* that Arneson most wanted to outrage and *his* human condition that he revealed; but in doing so, he gave every empathic viewer a fresh inroad into themselves. As one longtime collector of Arneson's work

FIGURE 1
Noble Image, 1961
Estate of Robert Arneson

explained, his art gave her "permission" to explore feelings she found in herself but was not going to act out on her own.[4]

Arneson's subject matter, like Pollock's, centered on his identity. But where Pollock immersed himself in the turmoil of his psyche, Arneson looked more outward, kept a certain distance; his body, his self-image provided instruments for examining the interface with the world. He admired the depth of the New York school's existentialism as these artists in turn had admired the aesthetic achievement of the European moderns, and yet, like Pollock's, Arneson's identity was steadfastly American, rooted in the American West. The surface handling and spontaneity of form in Arneson's early ceramics demonstrate that by 1959 he was already engaged in the dialogue with abstract expressionist painting—especially with that of Pollock and Guston—that would continue throughout his career.

Yet whenever Arneson moved too far into "serious" content, jokes invaded the sanctum of sober reflection. It was in his ceramic sculptures of toilets from 1963–65 (fig. 2) that Arneson finally recognized this as a characteristic of an artistic voice that was uniquely his own: "I had finally arrived at a piece of work that stood firmly on its ground. It was vulgar, I was vulgar."[5] His 1988 sculpture *Temple of Fatal Laffs* (fig. 3) seems to acknowledge, in retrospect, this suffusion of contemplative depth with humor as a central tenet of his artistic persona.

11

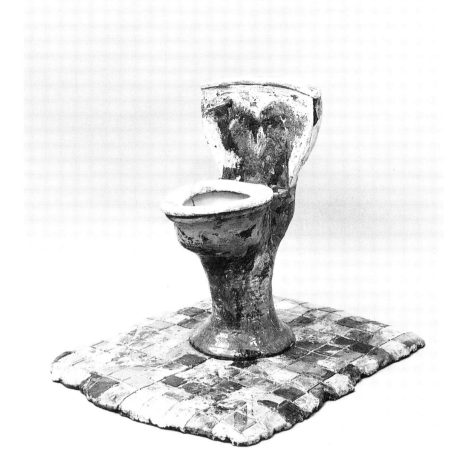

Arneson labored the entire summer of 1965 on a serious ceramic self-portrait—his first self-portrait in clay (pl. 1). It began as a rather academic likeness with which he intended to get away from "the silly stuff,"[6] as he described it (away from works such as the *toilets* and the jokey *Kiss It Penis Trophy* of 1964). When the piece came out of the kiln he photographed the humorless self-likeness; he even photographed himself with it. But before long he felt compelled to "fix" it; something didn't look right. So he started reworking the glazes on the piece and put it through several glaze firings until eventually it cracked in the kiln—from the chin, in a widening fissure, all the way down the front. He was distraught.[7] Then, on an impulse, he glued some marbles into the crack in the chest to look as if they were spilling out, turning the "serious" self-portrait into yet another wisecrack.

Humor helps the psyche integrate difficult emotional content, and this self-portrait involved a charged subject matter (the artist's own body image with all of its symbolic derivatives) and the imposition of difficult restraints in representing it (most obviously by attempting a sobriety that was out of character and which, in itself, short-circuited the artist's habitual mechanisms of psychic defense in humor). The disturbing deformation of the eyes—one a gaping orifice and the other a pinhole—suggests the intensity of this examination of the artist's body image which had already sustained an assault in childhood from his congenital deafness.

The boundaries transgressed by a joke are, on the most fundamental level, fortifications against disturbing emotions on the frontiers of the self; jokes negotiate a treaty when those stockades have been compromised. Freud described the mechanism in this way:

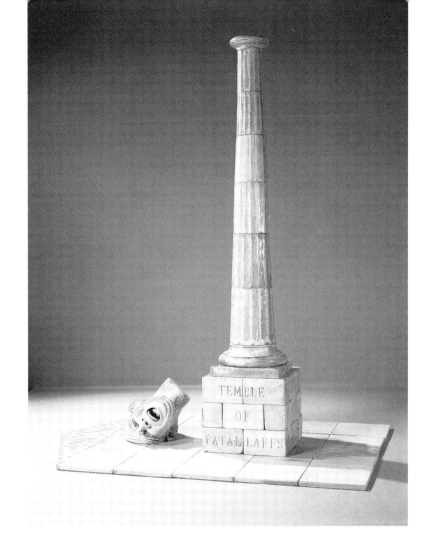

FIGURE 3
Temple of Fatal Laffs, 1989
Collection of the Contemporary
Museum, Honolulu

The ego refuses to be distressed by the provocations of reality, to let itself be com-
pelled to suffer. It insists that it cannot be affected by the traumas of the external
world; it shows, in fact, that such traumas are no more than occasions for it to gain
pleasure. This last feature is a quite essential element of humour.... Humour...
signifies not only the triumph of the ego but also of the pleasure principle, which
is able here to assert itself against the unkindness of the real circumstances.[8]

The analyst Robert Waelder illustrated this dynamic with the memorable account of a
French aristocrat during the Revolution who stumbled while ascending the steps to the guillo-
tine and, turning with a smile to the spectators below, announced: "A superstitious Roman
would now have turned back."[9]

After *Self-Portrait of the Artist Losing His Marbles* Arneson did not do another self-por-
trait bust for six years. Instead, he focused on his tract house on Alice Street in Davis, Califor-
nia, and the events and things in and around it—kitchen and bathroom fixtures, the roses in
the garden, plates of food, but above all portraits of the house itself in a variety of contexts
and "moods." The house became a surrogate body for the artist, the events of his life were
recorded on it, and on occasion it would have "dreams of a better world," as he described one
rendition.[10]

Arneson returned to explicit self-portraiture again, on a major scale, with *Smorgi-Bob,
the Cook* (1971; fig. 4). The reasons for which self-portraiture moved into the normative cen-
ter of Arneson's œuvre at this time are various: "I can poke fun at myself, I know myself bet-

ter than anyone else, and I'm free," he half-kiddingly told students at the San Francisco Art Institute in 1979.[11] But this turn of events is also a logical outcome of his engagement with the "autographic brushwork" of abstract expressionism and all that that symbolized.

"A painting that is an act is inseparable from the biography of the artist," Harold Rosenberg wrote in his famous essay on the American action painters.[12] The act of making an object for Arneson was always a trial-and-error affair that evolved in the process of fabrication. In ceramics, especially, many unexpected things occur in the kiln, and at each stage (particularly after each firing), Arneson would look at a piece with a remarkable openness to new possibilities that had entered into what he often referred to as "a dialogue" with the object. He would reevaluate the sculpture after each step and decide whether to stop there or to take it further in one direction or another.

On Rosenberg's model, the dialogue with the object was ultimately the artist's introspective discourse with himself. Arneson's move into self-portraiture only made that literal, extending what was already present in the surface treatment of his works of the early sixties and in the obliquely psychological subject matter of the Alice Street house, the domestic images, and the anthropomorphic bricks of the late sixties and early seventies.

Nevertheless, Arneson maintained an emotional distance in his self-portraits, objectifying himself as though observing from the outside the interface of his person with the world. As late as 1989, he would remark: "I never did a self-portrait. I always use a self-portrait as a mask."[13] When Arneson first returned to large-scale self-portraiture in the seventies, even the continuing formal dialogue with painting took on a cooler tone.

In *Smorgi-Bob the Cook*, the artist metamorphosed into a three-dimensional schema (and thus turned inside out) the pictorial device of one-point perspective, which has remained the central principle for representing illusionistic space in Western painting since the Renaissance. He fashioned this tableau into a perfect, receding triangle and then capped it off with lines of recession all converging on his head. This ironic transformation of a formal device into a deliberately childish way of "pointing to himself" parodies all the then-fashionable talk about flatness, illusionism, and "the framing edge" in the pretentious art jargon of the late sixties and early seventies. At the same time, Arneson was also taking a shot at the high-art prejudices about clay in giving *Smorgi-Bob* the finish of shiny, porcelain dinnerware—which is what potters are *supposed* to make anyway—and since the ceramic artist "cooks" his art in a kiln, Arneson here sarcastically celebrated his achievement as a master chef.

Smorgi-Bob engages Arneson's concern with the issues of painting in a more cerebral way than the surfaces of his funk sculpture of the sixties. "My work," he noted in 1974, "is not about sculpture in the traditional sense, volumes and planes,...I am making drawings and paintings in space."[14] Likewise, *Classical Exposure* of 1972 (pl. 3) has less to do with the autographic possibilities of a gestural surface than with philosophical issues about the body (notably those raised by the feminists in the seventies in relation to the frequent objectification of women's bodies in art and photography). A number of feminists at that time turned their attention to the male body; in 1972 *Cosmopolitan* magazine published a much discussed nude foldout of Burt Reynolds with a cigar in his mouth (lampooning the nude foldouts in *Playboy*), and in *Classical Exposure* Arneson seems to respond to that event by objectifying his own body.[15]

The proponents of academic criticism (and academic art)—whether the purveyors of the nineteenth-century Salon, or Clement Greenberg and the supporters of his formalist canon in

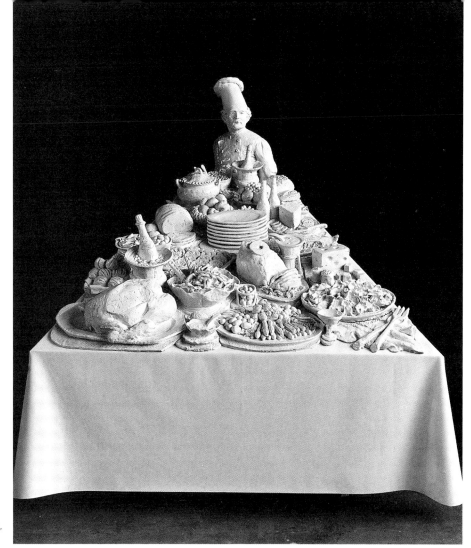

FIGURE 4
Smorgi-Bob, the Cook, 1971
Collection of the San Francisco
Museum of Modern Art. Purchase,
72.38A-CC

the sixties, or the many academic writers who are surfing one or another of the waves of critical theory today—take for granted that "important" advances in culture (Greenberg's term) derive from theory. But many artists' motives are more visceral than that; here Arneson wanted "to see it," to experience what it would be like. Central to Arneson's œuvre is his persistent assault on the separation of high art from the mundane events of lived experience, which always lie at the foundation of great works of art.

That is also what makes Arneson's work radical—the directness of his encounter with the unacknowledged aspects of prosaic reality, the things that most of us choose to deny in ourselves until somebody else gives us not only permission to look at them, but a fresh way of doing so. Such propositions are inevitably treated by high-brow critics as kitsch: "I must say that the grotesque aspect of [Manet's] contributions has two causes," a French critic wrote of the Salon in 1865: "first, an almost childish ignorance of the fundamentals of drawing, and then, a prejudice in favor of inconceivable vulgarity."[16] In our time, this psychological denial (as vulgar, retrograde, not serious) has become recklessly sweeping, as in Benjamin Buchloh's casting off of the "outmoded concepts of originality and authorship,"[17] or Hal Foster's casual dismissal of the entire œuvre of Robert Rauschenberg because, as Foster wrote, his attempt "'to reconnect art and life,'...read[s] as farce."[18]

Classical Exposure is certainly vulgar and politically incorrect. It frankly occupies itself with the common experience of a man living on the cusp of the American sexual and sociopolitical revolution of the early seventies. The piece is an oxymoron in title and form that sets the unseemly assertion of bodily reality off against the high seriousness of an austere classical tradition—"I have a colleague in art history who told me I must get more classical in my work."[19]

JONATHAN FINEBERG 15

At first sight this monochrome self-portrait appears like a Roman terracotta. It is an idealized, heroic type, undermined by unheroic detail. The bust of the artist chomping on a fat cigar rests on a Tuscan column with the artist's genitals hanging off the front (no less startlingly irreverent for having been inspired by classical herms). He even subverted the solidity of the column by showing his toes peeking out under the molding at the base as though it were a supple skirt. Beneath the facade, and visible from the back, is an underlying structure of bricks with the neck serving as the chimney for a crude brick kiln. Implicitly, the elevated institution of art history itself is challenged by these "unelevated" details.

Assassination of a Famous Nut Artist (pl. 2) is a ceramic "cartoon" self-portrait, based on a drawing by the artist's teenage son Kreg in a moment of Oedipal *excelsus*. The artist is having his brains blown out by a gun connected to the head by a spurt of flame and a little puff of smoke, as in an action comic book. Meanwhile, both a knife and an arrow plunge deeply into the neck from opposite sides—the eyes cloud over, a disgusting glob of snot exudes from the nose, the mouth contorts in agony, and blood runs and splashes in all directions. The artist completed this inventory of wounds (to the body image) with an ugly wart on the right temple and a hearing aid in the left ear. Arneson made the piece in the midst of a tumultuous transition from one marriage to another, and the work is simultaneously gorgeous in its rich colors and sensuously molded forms, hideous in its descriptive details, and detached in its cartoon style. The reference to the formal language of the comics is of course part of its essential "vulgarity." The piece is charged with psychological turmoil, and yet the adolescent jokiness might allow someone disposed to avoid its content to dismiss it as childish.

A little further along in his essay on "Humour," Freud observed that "the subject is behaving towards [jokes] as an adult does towards a child when he recognizes and smiles at the triviality of interests and sufferings which seem so great to it. Thus the humourist would acquire his superiority by assuming the role of the grown-up...and reducing the other people to being children.... [T]he subject suddenly hypercathects his superego."[20] This observation illuminates the position of both the artist who uses humor to negotiate psychic stress and in another way the critic who dismisses work that relies on humor.

One day in February 1975 Arneson suddenly started hemorrhaging and was diagnosed with bladder cancer (probably contracted from chemicals in his art materials). He underwent immediate surgery (the first of what would be thirty trips to the hospital over the next ten years). When he was physically able to return to sculpture, he embarked on *Man with Unnecessary Burden* (pl. 4).[21] This over-life-size ceramic head in grisaille shows the artist looking up with an expression of inquiry and concern at a brown boulder resting on his head.

As in the funk toilets of the sixties, Arneson covered the boulder with graffiti: "oh shit" and "fuck it" seem to be two reactions to his discovery of the rock on his head (a stand-in for his concern about his illness). It is unclear whether "kiss it" has the sense of kiss it to make it better or kiss it goodbye, but "on my mind" is clear enough, and on the back side of the rock, the artist drew a brick (stamped "Arneson") flying through the air, about to shatter a four-paned window. Across the front of the sculpture he asked: "Is figurative art still possible?" These are questions about his own psychic integrity—whether his physical survival is as fragile as the pane of glass and if what he does is really art at all.

The germ of the concept for *Captain Ace*, a ceramic self-portrait of 1978 (pl. 5), predated *Man with Unnecessary Burden*; Arneson did a drawing called *Ace* at the end of 1974,

showing himself wearing a hat that seems to be the silhouette of a large bird of prey, and at the top of the forehead he collaged a magazine picture of a nest full of eggs (as in *Captain Ace*). *Captain Ace* portrays the artist with his finger up his nose, dressed in a leather flight jacket and an aviator's cap. On the back of the jacket under the collar the artist wrote, "850138" and "AUTHENTIC WORLD WAR 2 FLIGHT JACKET. GOATSKIN GRAIN EMBOSSED LEATHER WITH WIDE PILE COLLAR." The latter inscription may have come from a mail-order catalogue, and Arneson did own such a jacket, but the reference clearly also concerns his brother Vernon, a World War II pilot who was shot down over Germany and spent the last fifteen months of the war in a Nazi prison; the number may come from Vernon's military dog tag.

Meanwhile, a wild turkey roosts on *Captain Ace*'s head, laying eggs *and* droppings. Wild Turkey is the brand name of a potent bourbon whiskey that Arneson used to keep in the studio; here he puns on the idea of the bomber pilot "getting bombed" on Wild Turkey. Arneson stamped "MELEAGRIS GALLOPAVO" (the Latin name for the wild turkey) on the piece—he had a *Webster's Unabridged Dictionary* which he loved reading to get ideas for inscriptions, and that is probably where he found this one. But on the back of the bust itself, beside a graffito of a half-figure angel, the artist wrote a chilling reflection on his ongoing struggle with cancer: "GOTTA DATE WITH AN ANGEL."[22]

In 1974, during a retrospective at the Museum of Contemporary Art in Chicago, Jack Lemon of the Landfall Press persuaded Arneson to make some lithographs. These prints refocused the artist on drawing, first for the editions themselves, but then as works on their own. From 1974 through the late eighties, Arneson produced a body of large, finished drawings in a loose, gestural style that reflects his continued preoccupation with action painting. He also painted Pollock-like splashes of color on the base of *Klown* (pl. 7) and on several other sculptures of the late seventies as he seemed to concentrate again on the expressive possibilities of glazing as a kind of gestural painting.

In *Captain Ace*, Arneson left the lower part of the neck and the lower front of the jacket raw, taking obvious pleasure in letting the beautiful rivulets of dripping glaze come down from the sections above. In 1982 Arneson took up Jackson Pollock explicitly as a subject, attracted by the juxtaposition of Pollock's extreme emotional anguish and the lush, sensual beauty of his surfaces. This same juxtaposition characterized works by Arneson like *Eye of the Beholder* (pl. 17)—a visually opulent self-portrait drawing of 1982 with a subject almost too gruesome to look at (the artist gouging out his own eye with his forefinger).

Meanwhile, *Klown* also signaled a new directness in the physicality of what is described in the work. "That's *me* inside that white skin of a head, attempting a tongue-in-cheek U-no-Hu self-portrait," he explained,[23] and "U NO HU" is stamped across the front of the collar. But trapped under the funny mask, the artist seems choked, victimized, and disoriented. This work addresses a palpably physical sensation of discomfort.

In his sketchbooks of the period, Arneson was looking at both the distortions of a self-portrait sketch by the seventeenth-century Flemish artist Adriaen Brouwer, pulling faces in a mirror,[24] and the psychologically impenetrable grimacing self-portraits of the eighteenth-century psychotic sculptor F. X. Messerschmidt.[25] But Arneson provides the key source for this sculpture in a drawing entitled *Clown* (pl. 6), a study for *Klown*. Onto the drawing, Arneson collaged a postcard of *White Clown*, a painting by George Luks (fig. 5). The Luks work shows a clown with his head and neck completely covered in a shell of white paint—the lips are

black, the eyes pressed shut into a thin black cross, with only the ears and the tip of the nose visibly flesh-toned, though slightly too saturated with reds and oranges. The red ear, the white mask, the wide yellow collar, and the tortured entrapment of the faintly disclosed face underneath the mask in *Klown*, all derive from suggestions in this painting by Luks. Above the postcard on the drawing, Arneson has written, "Just Borrowing."

All over the surface of *Klown* the artist created a visual and verbal skin of jokes; he repeated "HA HA HA!" over and over in different places and stamped phrases like "HAIR BRAIN," "NOVEL NONSENSE," "LOKO" and puns on the art world such as "WHO WERE THE HAIRY WHO?" (referring to the group of Chicago imagists of the late sixties and early seventies) or sarcastic remarks ("AND DID YOU HEAR THE ONE ABOUT ANDY WYETHS ELECTION TO THE USSR ACADEMY OF ARTS"). But hanging the clown's purple testicles around his neck in the place of a bow tie and giving the self-portrait below the mask an expression of anguish suggest another, more visceral content.

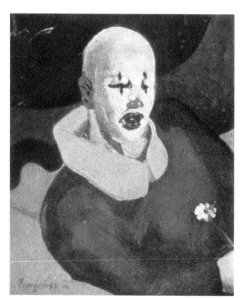

Typically, Arneson would record his train of (sometimes quite personal) thought as he worked. When he made this sculpture, he had been flying to the Livingston Clinic in San Diego once a week to try alternative medical treatments for his cancer—massive doses of vitamins, a special diet, and an enema called "Wobbie Mugas," which the doctor there believed could purge the body of toxins (a treatment Arneson shortly abandoned). So, on the back of *Klown* it says, "OH WOBBIE MUGAS THE COO JUICER." "NASAL OFFICER," lettered just under a medieval foot soldier wearing a helmet that goes down over the nose, may refer to one of Arneson's famous sinus infections, and the sentence "LET'S JUST SAY HE'S A HOT FOOTED, LOOSE FOOTED, SLOUGH FOOTED STOMPER IN THE MUD AND A REGULAR CRACKER TO BOOT" may have resulted from somebody's asking him for an artist's statement that he was thinking about as he worked in the studio or from a pop song he heard on KPFA, the left-wing public radio station from Berkeley that he played almost constantly in the studio.[26]

It may be too obvious to point out that *Klown* once again raises the issue of the separation of high and low by employing a subject associated with bad, art-fair kitsch (i.e., clown paintings), which at the same time draws on the pictorial tradition of the clown as a metaphor for the artist as outsider, as in the saltimbanques of Daumier and Picasso. Bruce Nauman's *Mean Clown Welcome* (a neon work of 1985) and his *Clown Torture* video of 1987 (fig. 6) also interestingly engage both meanings.

The focus changed in Arneson's work of the eighties. In 1981 the city of San Francisco commissioned Arneson to sculpt a portrait of the late Mayor George Moscone for a new convention center named in his memory. The head Arneson made captured Moscone's likeness to everyone's satisfaction, but the notations on the pedestal referring to Moscone's life—including the controversial events surrounding his assassination—caused the mayor of San Francisco to reject the piece. This in turn created a national scandal.

Barely two weeks later Hilton Kramer, the art critic for the *New York Times*, savaged Arneson's work in a review of an exhibition at the Whitney Museum in New York called

"Ceramic Sculpture: Six Artists." In short, Kramer argued that important art had to be serious—no jokes!—and that a serious artist would not be working in clay or living anywhere but in New York. The artist responded in a brilliant send-up of Kramer's prejudices in a self-portrait of 1982 called *California Artist*. "I tried to re-create that person they were talking about," Arneson explained.[27]

California Artist (pls. 13 and 16) sits on a disintegrating pedestal with a marijuana plant growing up the side and empty beer bottles lying around the bottom. At the back a squirrel stashes a nut in a hole, as if to imply that the artist who stares blankly forward with his arms folded is a "nut" too; Arneson often referred to the work of his circle as "nut art." The artist wears a faded blue-jean jacket, open down the front to expose his hairy navel, and through the black holes of his sunglasses one can see the emptiness of the head, glazed inside with an airy Catalina blue. The parody reads like a page from the calendar of Pudd'nhead Wilson.

Arneson's ongoing struggle with cancer, which had seemed especially dire in the winter of 1979–80, on top of the critical attack in the *Times* and the Moscone affair, must have affected his frame of mind. But the publicity over the Moscone piece also made him realize that he now had a platform from which to take up a cause.[28] So at the end of 1982 Arneson turned to a theme so sober it shocked even longtime admirers. He turned to a body of horrific images of nuclear holocaust and savage militarism, which the artist felt to be terrifyingly possible during the Reagan presidency.

Although the self-portraits trailed off in favor of the antinuclear work, the anguish in such pieces as *Klown* and the avenging demons of the antinuclear works began to come together in an intensifying obsession with the tragic myth of Jackson Pollock. Arneson voraciously read all the literature on Pollock and his art (he even made a pair of Jackson Pollock bookends for the volumes he had acquired on the subject). In several works of the later eighties—including *Disguise, Me and J, Me and Jackson*—Arneson conflated his own image with that of Pollock. He also made a pilgrimage to Pollock's former studio in East Hampton and immersed himself in the myths and demons of Pollock's subject-matter, culminating in a mon-

JONATHAN FINEBERG 19

umental sculpture based on Pollock's *Guardians of the Secret* (1943, San Francisco Museum of Modern Art).

In 1984 surgeons in Vallejo and Los Angeles removed and reconstructed Arneson's bladder in a complicated pair of operations, after which they had some real hope that they had eliminated the cancer. But the worry never went away and ultimately neither did the cancer. When Arneson began turning his attention back to self-portraiture in 1988, he did so in the context of a more direct exploration of his own mortality. These late self-portraits took on a universality and a philosophical depth that equaled, and even surpassed, the breadth of humanism in the nuclear works. Then in a series of red conté crayon drawings of 1991 and a related group of self-portrait double masks, Arneson announced a late style (pls. 24–30). The conté drawings have an abbreviated, loose line that distinguishes them markedly from the more descriptive line and shading of earlier drawings; the masks (such as *Head Eater* [pl. 30], *Bugs* [pl. 29], and *Earth Angel Mine* [pl. 25]) embody the unruly forces of the unconscious mind, the physicality of the human condition, and the spiritual transcendence of the human imagination in empathically evocative, exaggeratedly physical interactions between multiple images of himself.

In 1991 and early 1992 Arneson also embarked on a group of large self-portrait bronzes, such as *Poised to Infinity* (pl. 34) and *Pedestal for Self-Evaluation*, which have a kind of timeless monumentality (in style more than in actual size, though they are relatively large). Then in the spring, prompted by yet another bout with the cancer, Arneson began chemotherapy. "I think im OK," he wrote in April 1992 on the back of a postcard of his sculpture *Poised to Infinity*. "Cancer got my R Kidney—not a great surprise.... Now im on chemo for the next 4 months and taking things a bit easy although I try to get to the studio daily—Great therapy.... So we are doing Chemo to finally end this saga. They promised!... p.s. Thank god everyone else is healthy!"[29]

Just as Arneson bluntly assaulted his own head, hung his penis on a column, and self-effacingly joked about his achievements as a "master chef" in his self-portraits of the seventies, he also put this private experience of his own body and psyche into the public sphere with two astonishing works called *Chemo 1* and *Chemo 2*, done in the spring of 1992 (pls. 47–52). His rendering of his own physiognomy is based on a prematurely aged and hairless (from the chemotherapy) head, monstrously deformed by the aggressive assaults of both disease and cure on his body.

As prefigured in such self-portraits as *Fragment Face* of the previous year and the bashed-in bronze self-portraits of the early eighties (*Massetered, Pour Walla, You Don't Belong Here...*[pl.11]) these large, formal busts embody a nightmare of personal disintegration. He cannot have missed the irony in his deadpan inscription of the informational sheets from the medicines or perhaps the entry in a medical encyclopedia on the pedestals: "SIDE EFFECTS NEEDING IMMEDIATE MEDICAL ATTENTION SWELLING OF FACE; UNUSUALLY FAST HEARTBEAT; WHEEZING. HEARING PROBLEMS ARE MORE LIKELY TO OCCUR IN CHILDREN. CIS-PLATIN [surrounded by a starburst of hatchmarks] PRONUNCIATION SIS-PLA-TIN COMMONLY REFERRED TO AS: CIS-PLATINUM. BRAND NAMES: A COMMONLY USED BRAND NAME IS PLATI-NOL. HOW GIVEN: CISPLATIN IS GIVEN BY IV INJECTION. SPECIAL PRECAUTIONS: WHILE YOU ARE RECEIVING CISPLATIN YOUR DOCTOR MAY WANT YOU TO DRINK EXTRA FLUIDS SO THAT YOU WILL PASS MORE URINE. THIS WILL HELP PREVENT KIDNEY AND BLADDER PROBLEMS."

Arneson's last drawing, *Narcissus Reappraised* (pl. 31), was tacked to the wall in his drawing studio at the time of his death from cancer on November 2, 1992. It shows the artist with a gaunt face and a nearly hairless head, as he appeared when recovering from chemotherapy in the early summer. It is neither a flattering nor a humorous portrayal, but a disconcertingly frank look at his physical presence in light of the knowledge of his impending death. A disembodied finger points to the long surgical scar across the top of his abdomen and another gestures at a hole punched in the belly, just below the navel. The head, so large and so prominent in his work since 1971, is here almost diminutive in relation to the torso.

Yet in the title, *Narcissus Reappraised*, the artist refers sarcastically back to his trademark of the seventies and eighties, his obsessive self-portraiture, while at the same time brutally confronting himself with the reality of an aging body that shows the ravages of an eighteen-year-long illness. The arms and legs—broken off, as in the poster of a Greek marble torso, pinned to the left of *Narcissus* on the studio wall—take on an altogether different meaning from their heroic source, serving here as the wounded appendages of a scarred physique set into a sepulchral black ground. On the wall above *Narcissus* the artist put a picture torn from a travel magazine of a shiny black nude—the opposite of Arneson's own failing body—the beautiful, muscular form of an African male, standing in front of a village of grass-roofed huts. The anonymous photo beside it, of a taut, young Caucasian torso from navel to chin, appears to have provided "notes" for the shading of the breast in *Narcissus*. But the artist worked chiefly from a sequence of matter-of-fact Polaroid snapshots he had taken of himself standing nude in the studio.

As in all of Arneson's work, this drawing is a blunt and poignant reflection on his own "human condition" at this particular moment in time, at this particular crossroads of his intellect, his physical being, and the world. With *Chemo 1* and *Chemo 2* he passed through his "Season in Hell"[30]—coming to terms with the torment that every artist, every human being goes through en route to a truce between one's spiritual identity and one's own organic reality. "Painting is a state of being...self-discovery. Every good artist paints what he is," Jackson Pollock told Selden Rodman just eight weeks before his tragic death.[31] "Are you trying to be funny?" Arneson wrote to himself at the end of a long passage in his notebooks. "No, just trying to be."[32]

NOTES

I want to acknowledge here the many, many hours of absolutely essential help I received from Sandra Shannonhouse, the artist's widow. Though I was Bob's friend for the last dozen years of his life and feel I knew him reasonably well, she helped me understand much about Arneson the man and Arneson the artist, from technical and aesthetic issues to critical biographical references, which I could never have found on my own, to fundamental human questions. All of us who are engaged with the work of this very great artist owe her a profound debt.

1. Arneson, September 1982, written responses to a questionnaire from the organizers of an exhibition of California artists, in the archives of the Estate of Robert Arneson. The orthography and punctuation are his.
2. Lee Krasner, "An Interview with Lee Krasner Pollock by B. H. Friedman," in *Jackson Pollock: Black and White*, exh. cat. (New York: Marlborough Gallery, 1969), 8.
3. Arneson, from a written statement dated by him to September 1982, in the archives of the artist's estate.
4. Gilda Buchbinder, conversation with the author, Chicago, October 12, 1996.

5. Arneson, transcript of a taperecorded conversation with Madie Jones, 1978, Archives of American Art, Smithsonian Institution, 44–46; cited in Robert C. Hobbs, "Robert Arneson: Critic of Vanguard Extremism," *Arts Magazine* 62, no. 3 (November 1987): 89.

6. Arneson, conversation with Jonathan Fineberg at Yale University, February 3, 1981.

7. Ibid.

8. Sigmund Freud, "Humour" (1927), in *The Standard Edition of the Complete Psychological Works of Sigmund Freud*, ed. James Strachey, vol. 21 (London: The Hogarth Press and the Institute of Psycho-Analysis, 1961), 162–63.

9. Robert Waelder, *Psychoanalytic Avenues to Art* (New York: International Universities Press, 1965), 58. Professor Stephen Fineberg pointed me to this remarkable account.

10. Arneson, faculty research lecture, "Alice Street and After," University of California at Davis, 1989.

11. Arneson, transcribed from a tape of his lecture at the San Francisco Art Institute in 1979.

12. Harold Rosenberg, "The American Action Painters," *Art News* 51, no. 5 (September 1952); reprinted in Rosenberg's anthology of essays, *The Tradition of the New* (New York: Horizon Press, 1959), 27.

13. Arneson, "Alice Street and After."

14. Arneson, quoted in Cecile N. McCann, "About Arneson, Art, and Ceramics," *Artweek* 5, no. 36 (October 26, 1974): 1; cited in Neal Benezra, *Robert Arneson: A Retrospective,* exh. cat. (Des Moines, Iowa: Des Moines Art Center, 1986), 93n.30.

15. Robert Hobbs pointed out this connection in a talk on Arneson's work at New York University in October 1993.

16. Ernest Chesneau, *Le Constitutionnel*, May 16, 1865; cited in George Heard Hamilton, *Manet and His Critics* (New Haven: Yale University Press, 1954), 72.

17. Benjamin H. D. Buchloh, "Andy Warhol's One-Dimensional Art, 1956–1966," in *Andy Warhol: A Retrospective*, exh. cat., ed. Kynaston McShine (New York: The Museum of Modern Art, 1989), 41.

18. Hal Foster, "The Crux of Minimalism," in *Individuals: A Selected History of Contemporary Art, 1945–1986*, exh. cat., ed. Howard Singerman (Los Angeles: Museum of Contemporary Art, 1986), 176.

19. Arneson, "Alice Street and After."

20. Freud, "Humour," 163, 165. See also Sigmund Freud, *Jokes and Their Relation to the Unconscious* (1905), in Strachey, *Complete Psychological Works of Freud*, vol. 8, 233–34.

21. In Arneson's notebook no. 2, the drawing for this piece has the alternative title *Man with H[eavy] Load on his mind.* The page shows three concepts for the head, and the boulder on one has the Alice Street house in it like a thought bubble.

22. I want to thank Marjan Boot, curator of the Department of Applied Arts at the Stedelijk Museum, for taking the time to carefully record all the inscriptions for me so that I might use them in this catalogue.

23. Arneson, written responses to questions on a form from the organizers of an exhibition of California artists, in the archives of the Estate of Robert Arneson.

24. In his notebook no. 3, next to sketches from Brouwer, the artist wrote: "Self portrait making funny face with hands from Adriaen Brouwer p. 93 World of Vermeer."

25. See Benezra, *Arneson: A Retrospective*, 53, 56.

26. These suggestions were made by Sandra Shannonhouse.

27. Arneson, "Alice Street and After."

28. Arneson, telephone conversation with Jonathan Fineberg, June 27, 1990.

29. Arneson, letter to Jonathan Fineberg, April 6, 1992.

30. Arthur Rimbaud, "Une Saison en enfer," in *Oeuvres complètes* (Paris: Editions Gallimard, NRF, Bibliothèque de la Pleiade, 1963), 217ff.

31. Jackson Pollock, in Selden Rodman, *Conversations with Artists* (New York: Capricorn, 1957), 82.

32. Arneson, notebook no. 3, page 130.

Plates
with text by

Gary Garrels, Elise S. Haas Chief Curator
and Curator of Painting and Sculpture

Janet Bishop, Andrew W. Mellon Foundation Assistant
Curator of Painting and Sculpture

Jonathan Fineberg

Early Self-Portraits

Self-Portrait of the Artist Losing His Marbles (pl. 1) reveals important, enduring traits about Arneson's working methods. There are lots of rules in ceramics about how to do things and Arneson knew them all. But he was consistently breaking those rules to get the effects he wanted. *Self-Portrait of the Artist Losing His Marbles* is a particularly important watershed for the artist in that after he had labored diligently on modeling the head and then it cracked from one too many firings, he found himself manipulating the piece in ways that ceramicists never did—keeping cracked pieces, incorporating found objects with glue. The accident liberated him technically, and later, he would regularly insist that his students build something, destroy it, and then rework it in order to free them, in the same way, from a sense of preciousness about the medium.

When Arneson returned to self-portraiture with redoubled focus in 1971, instead of modeling each head from scratch he made an expressionless, generic mold of his head and modified it for works such as *Assassination of a Famous Nut Artist* (pl. 2). It was a two-piece press mold with no undercuts so that Arneson could roll out a slab of clay, stamp it onto a piece of burlap, and flop it into the mold. Next he removed the burlap and pressed the clay into the form, let it dry enough to support itself, and then tipped the two pieces out of the mold and joined them with wet clay. The seam ran down the center, front and back.

Arneson made a similar but larger self-portrait mold in 1974 for pieces like *Man with Unnecessary Burden* (pl. 4). By that time he had also created a one-piece self-portrait mask mold; he used all of these molds in any given year, alternating them depending on the size of what he had in mind to make. He made portraits of Roy De Forest, David Gilhooly, Wanda Hansen, and many others beginning with self-portrait molds, then modeling and refining the form into the different portraits.

PLATE 2
Assassination of a Famous Nut Artist, 1972

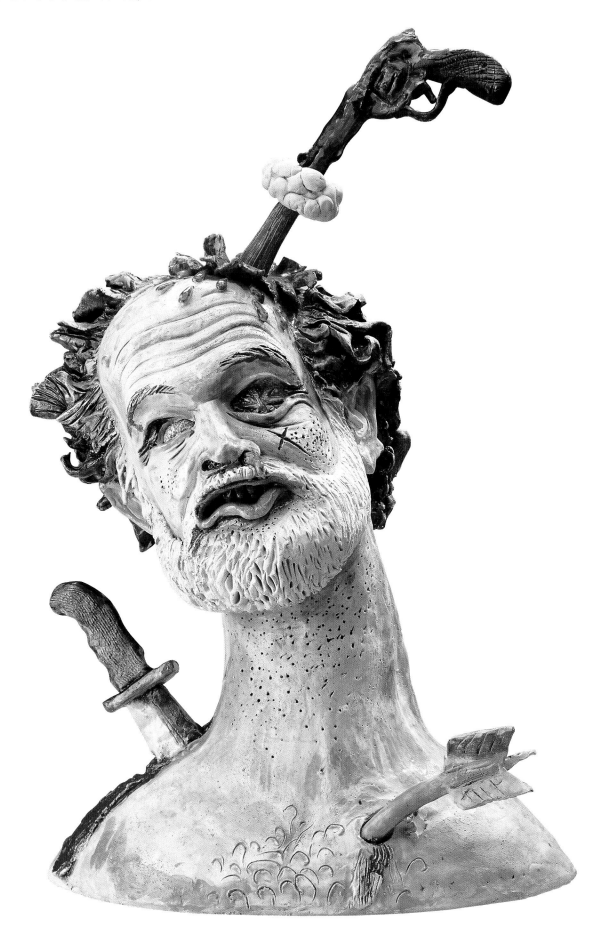

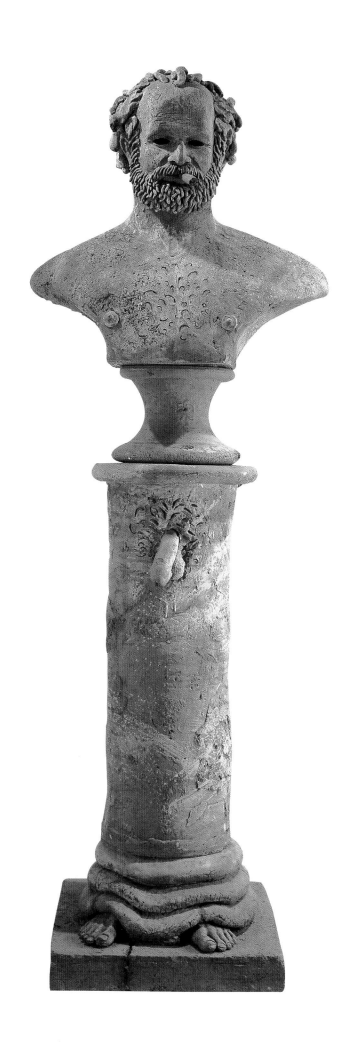

PLATE 3
Classical Exposure, 1972

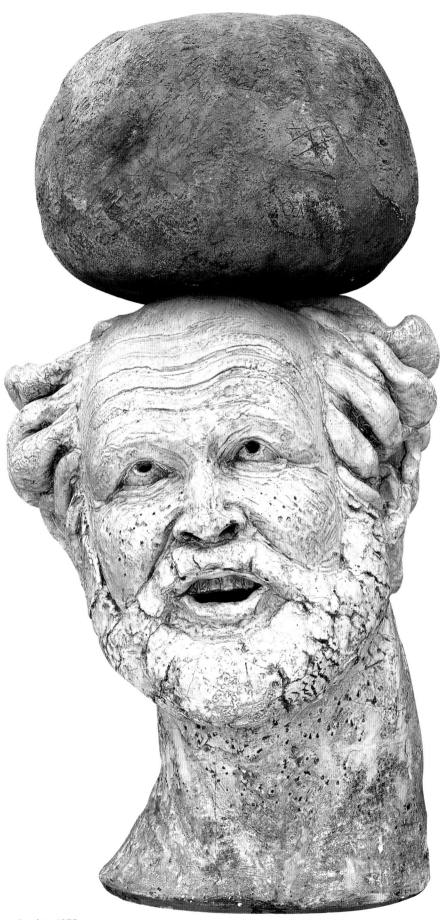

PLATE 4
Man with Unnecessary Burden, 1975

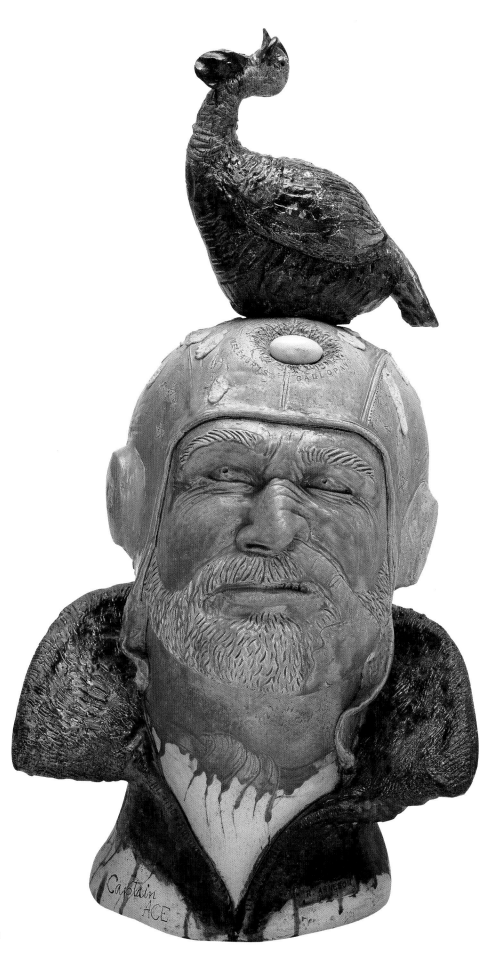

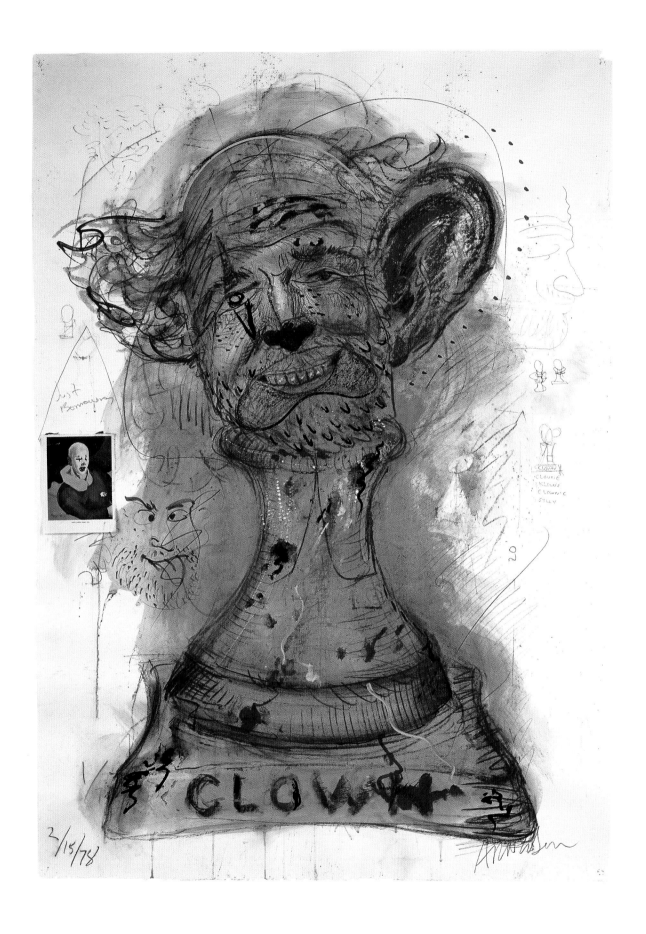

PLATE 6
Clown, 1978

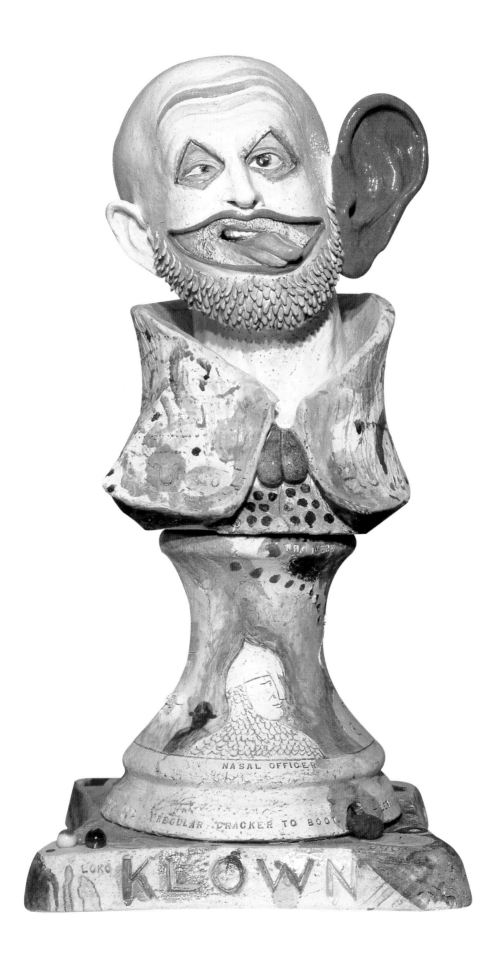

PLATE 7
Klown, 1978

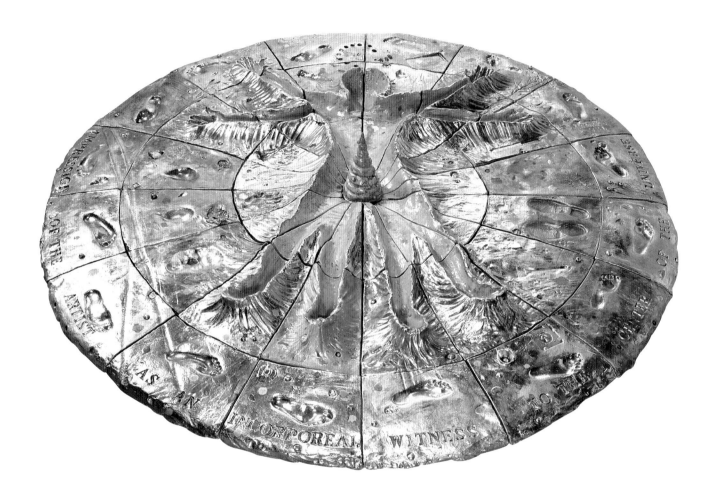

PLATE 8
*Impression of the Artist as an Incorporeal Witness
to the Center of the Universe,* 1979

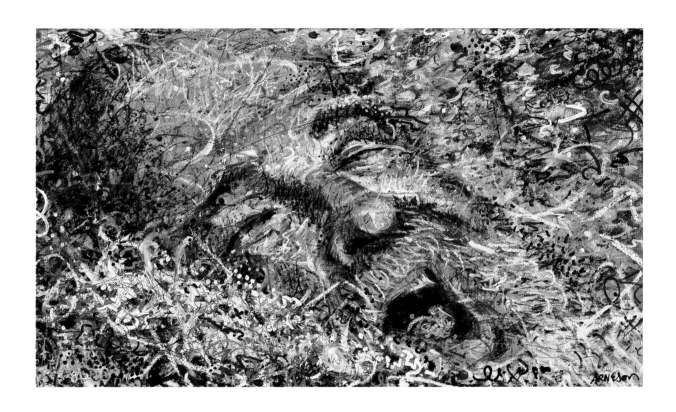

PLATE 9
Drawing for "Ikarus," 1980

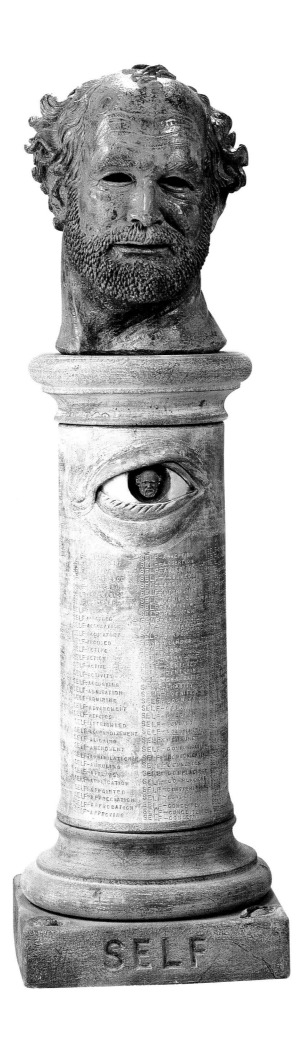

PLATE 10
This Head Is Mine, 1981

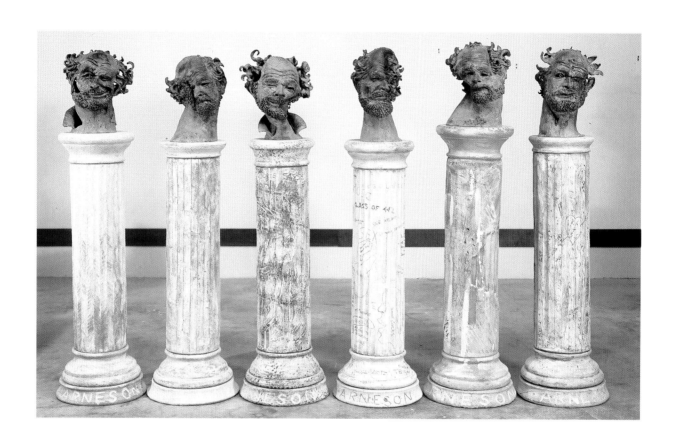

PLATE 11
Installation view of *Pour Walla*, 1981–82 (third from left)
Also shown (from left): *Sharp Focused*, 1981–82; *Head Fold*, 1981–82;
You Don't Belong Here, 1981; *Massetered*, 1981–82; *Heading Home*, 1981–82

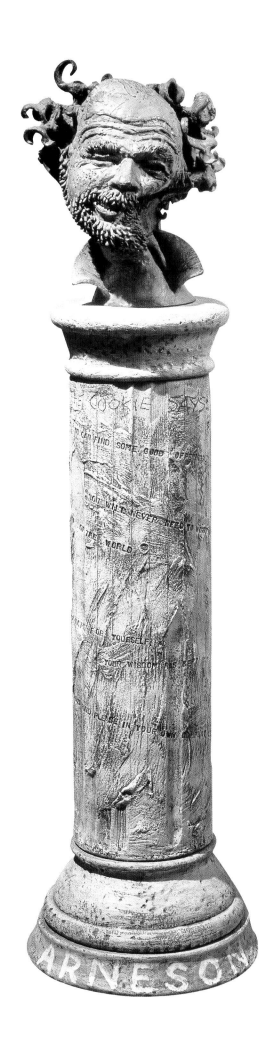

PLATE 12
Pour Walla, 1981–82

California Artist

Well, I really can't say or explain why I'm currently involved with the use and abuse of my own image. —Robert Arneson, 1982

With *California Artist* (pls. 13 and 16), made the same year as the noncommittal statement above, Arneson clearly had a point to make. In December 1981, just after the bitter experience of having his sculptural portrait of assassinated San Francisco–mayor George Moscone rejected by the San Francisco Art Commission, Arneson came under attack on the East Coast by Hilton Kramer in a *New York Times* review of an exhibition titled "Ceramic Sculpture: Six Artists."[1] Jointly organized by the Whitney Museum of American Art and the San Francisco Museum of Modern Art, the exhibition featured work by the Californians Peter Voulkos, John Mason, Ken Price, Richard Shaw, David Gilhooly, and Arneson. While praising Arneson's talents as a technician, Kramer lambasted him as the major figure of the part of the movement centered around the U.C. Davis art department that was unable to escape its own insularity. "It is in his work," the critic wrote, "that the prevailing spirit of this very different phalanx—a spirit best defined as defiant provincialism—is given its most protracted and energetic realization." Extending his individual viewpoint to that of others, Kramer concluded: "We are left, in short, with some dark thoughts about the fate of high art in the California sun."

Arneson's retort asserted the integrity of (Northern) California art through a pedestal piece that readily achieved iconic significance in the context of the artist's career. In this work, the artist defiantly amplified the critic's characterizations—using more "visual gags" and "sophomoric humor" to cast the West Coast artist as a quintessential hippie ne'er-do-well. Kramer had accused the artist's oversized self-portraits of bearing "a kind of moral smugness"; with *California Artist* Arneson added fuel to the fire. The torso of the figure sits on a ceramic base that looks like part of a building adjacent to an empty lot littered with beer bottles and a lipstick-smeared cigarette butt; a squirrel forages for nuts and a marijuana plant grows like a weed. The crumbling facade (revealing bricks stamped with the artist's surname) bears graffiti of a seated Buddha figure, who invokes California mysticism, as well as the popular World War II tag "Kilroy was here." Recalling the sculpture *Classical Exposure* (pl. 3), in which he truly let it all hang out, Arneson makes pointed reference to the pedestal as a stand-in for the lower part of his body by indicating genitalia in the anatomically correct place.

Preparatory drawings of August 1982 show the development of the sculptural concept for the upper body. In the August 22 drawing (pl. 14), the jeans-jacketed figure is exposed through his shirtlessness, but protected by his crossed arms and sunglasses. The beginnings of a tic-tac-toe game doodled over one shoulder suggest a parallel between the artist's activities and the idle passage of time. The study of August 26 (pl. 15) includes four collaged Polaroids showing the artist's upper body from different views, bare-chested and wearing his jacket. Executed in full scale (larger than life size), the study is clearly a working drawing with notes and measurements to assist in the translation of a two-dimensional image into clay. It also bears the note for the sculpture's punch line, "Cut out glasses into head—glaze interior of head with Catalina blue." Indeed, when one looks beyond the shiny silver eyeglass rims into the place where the eyes should be, one sees that the figure's head is completely empty. **JB**

1. Hilton Kramer, "Ceramic Sculpture and the Taste of California," *New York Times*, December 20, 1981.

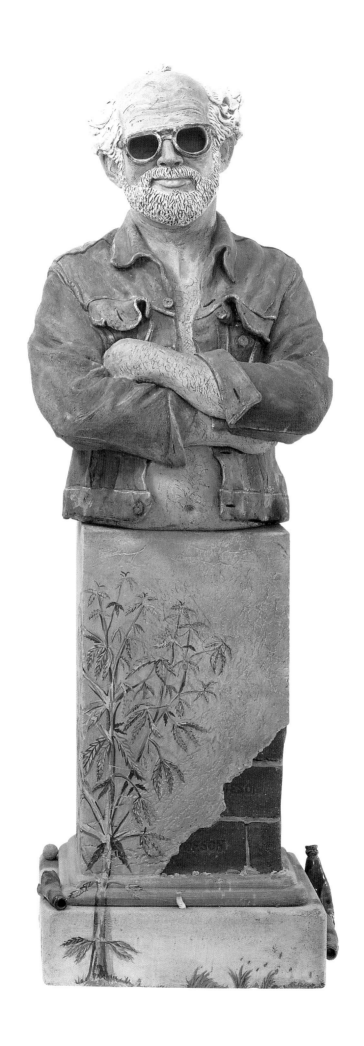

PLATE 13
California Artist, 1982

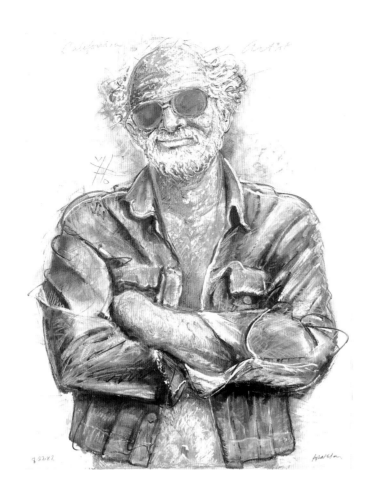

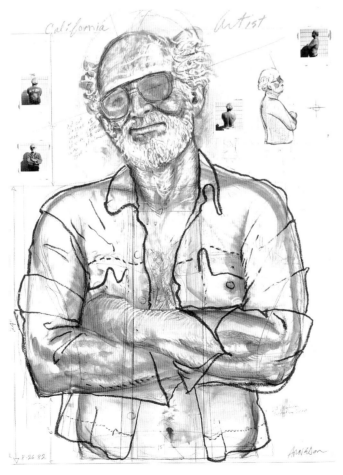

PLATE 14 (top)
California Artist, 1982

PLATE 15
Study for *California Artist,* 1982

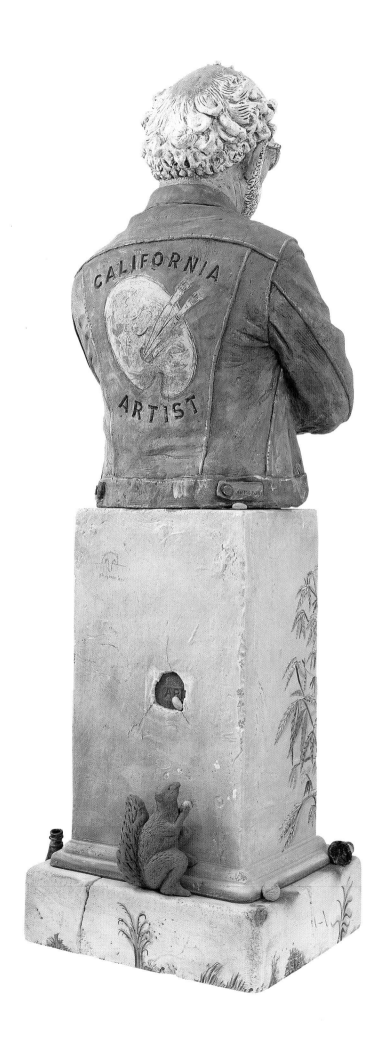

PLATE 16
California Artist, 1982
(rear view)

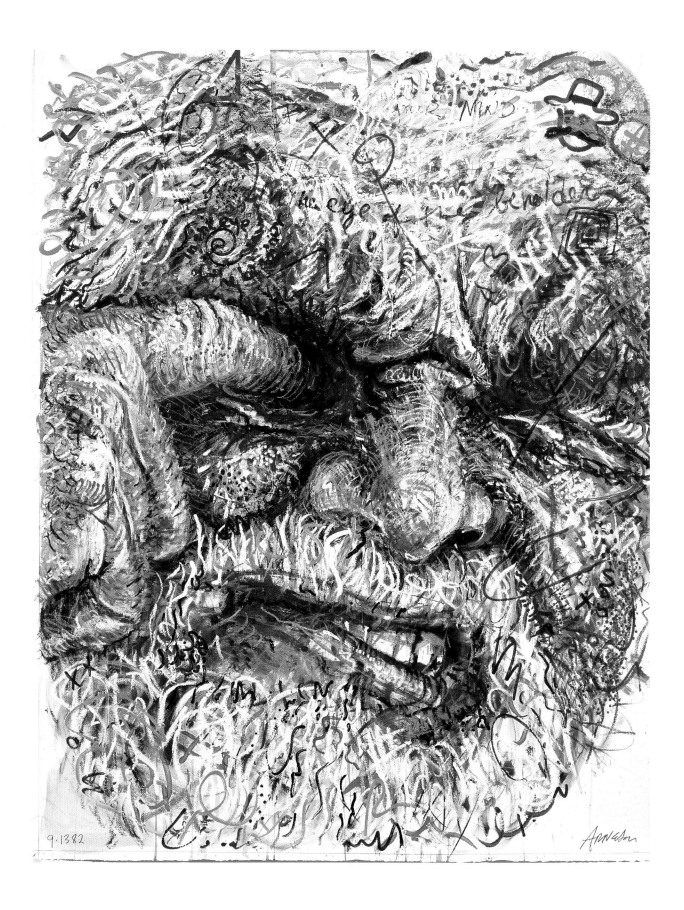

PLATE 17
Eye of the Beholder, 1982

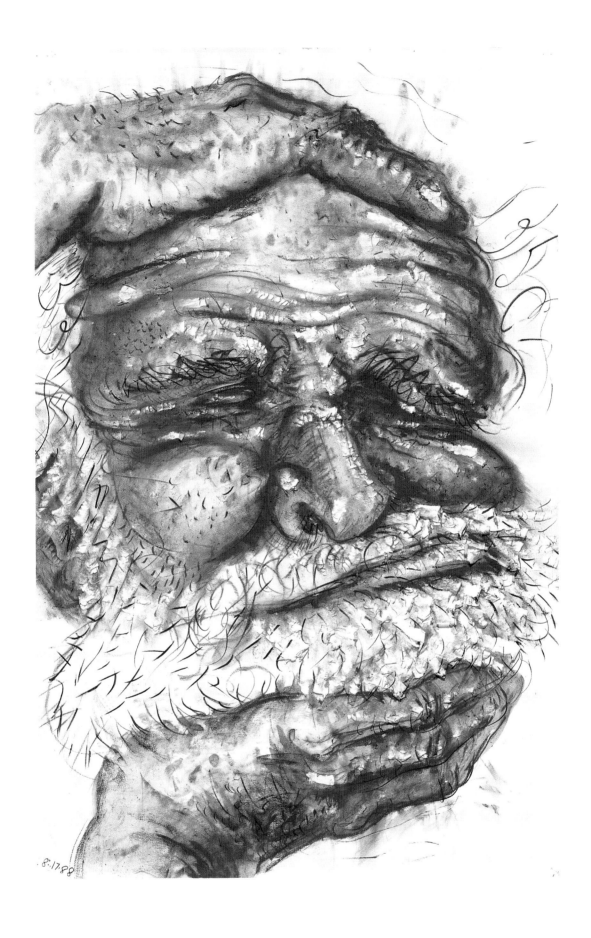

8:17.88

PLATE 18
Press, 1988

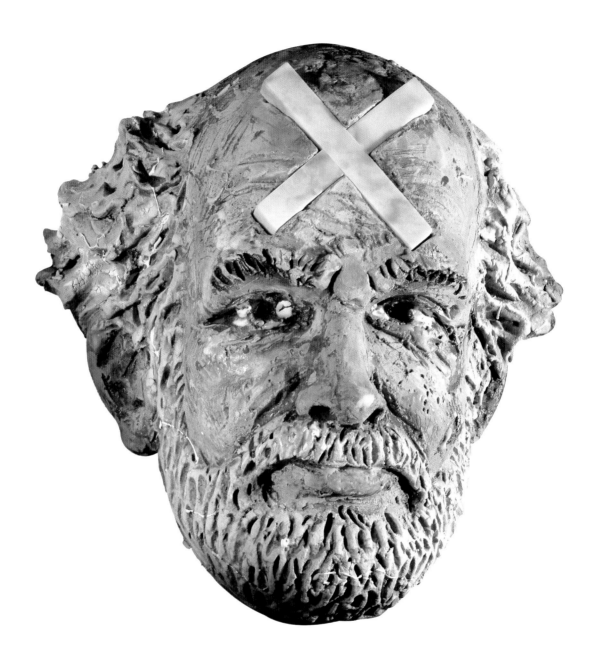

PLATE 19
Marble X, 1983

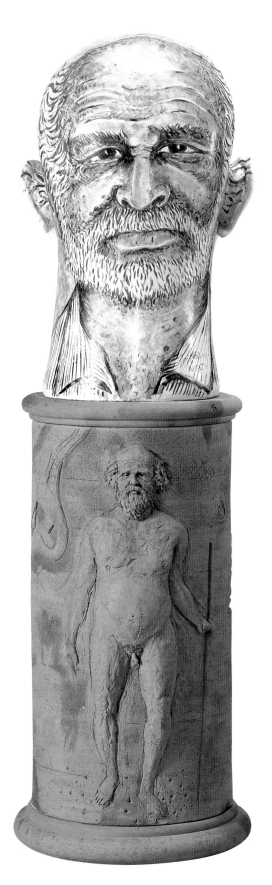
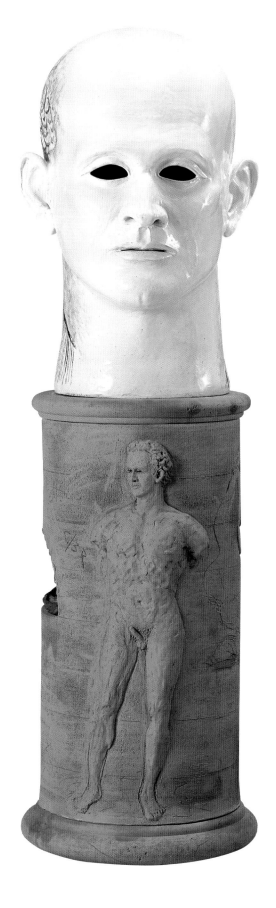

PLATE 20 (left)
35-Year Portrait, 1986–88 (front view)

PLATE 21
35-Year Portrait, 1986–88 (rear view)

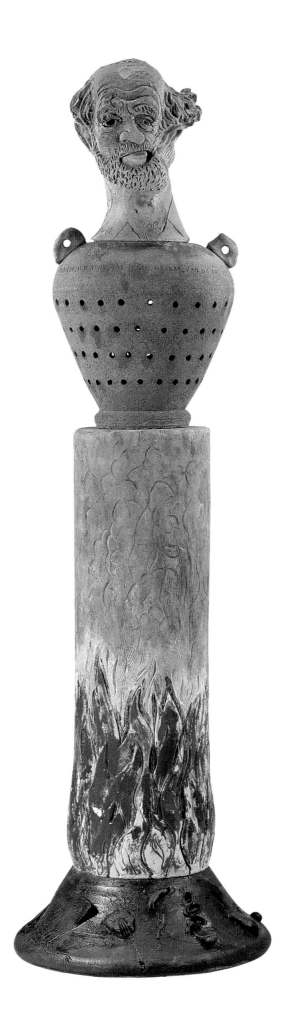

PLATE 22
Clay I Am, It Is True, 1982–83

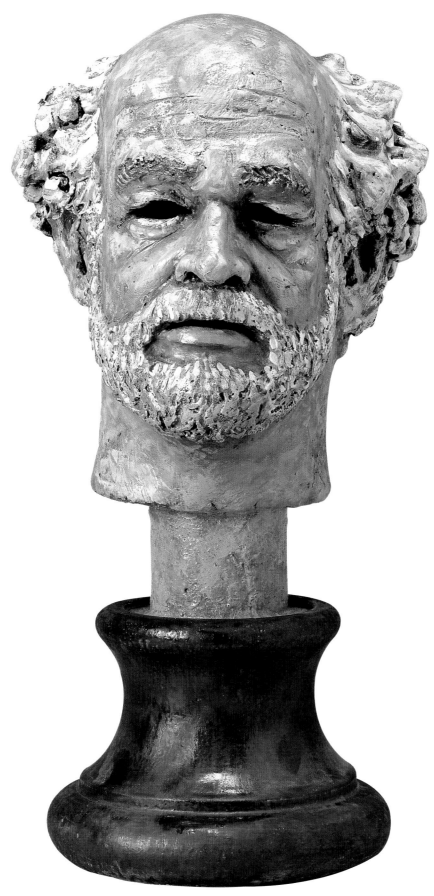

PLATE 23
Self-Portrait at 57, 1988

Reliefs

The relationship between likeness and life takes on another dimension in Arneson's series of double-headed reliefs. Not unlike Pygmalion, the mythical king of Cyprus who is said to have made a female figure of ivory that was brought to life for him by Aphrodite, Arneson appears to have truly cloned himself by presenting in each piece two self-portrayals.

If we consider the practice of self-portraiture, various layers of the self include the real person (the artist), perhaps the image of the artist reflected in the mirror, and the representation of the artist in the finished artwork. In the reliefs, however, two representations of one person now occupy the same realm, and it is difficult to interpret just what we are encountering. Are we seeing a self and an inner self? A self and a clone? Two "real" selves? Two clones?

It is natural to do a double-take when seeing twins. Given how we relate facial features to individuality, it is simply fascinating to see two people who resemble one another very closely. Yet Arneson's reliefs are startling not only because of the double likeness but because the two heads engage in direct physical dialogue with each other and thus call to mind the taboos associated with autoerotic and homoerotic behavior. In the drawing *Udder Decadence* (pl. 24), the artist uses a cow's udder like a Valentine's heart to frame an image of Arneson kissing Arneson. The artist has written out a few romantic lyrics from the 1950s Penguins song "Earth-Angel" and included a collaged image of a pair of full, dripping-wet lips. Another clipping underscores widespread public discomfort with physical affection between people of the same sex through a tabloidlike juxtaposition of Russian premier Leonid Brezhnev kissing East German leader Erich Honecker ("shocking" or at least "funny") with a young heterosexual couple ("normal") in a like position. Arneson presents a similar kiss in the relief *Earth Angel Mine*, and continues spirited expressions of affection in *Tongue Catcher* and *Ear Piece* (pls. 25, 26, and 27). Playfulness and perversity turn to decay, self-mutilation, and even cannibalism in *Bugs*, *Ear Ache*, and *Head Eater* (pls. 29, 28, and 30), where Arneson's doppelgänger is no longer his own best friend, but his own worst enemy. **JB**

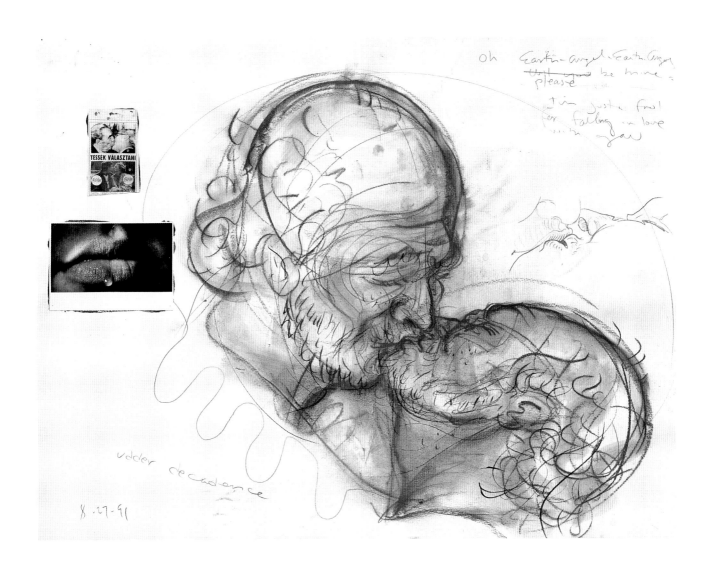

PLATE 24
Udder Decadence, 1991

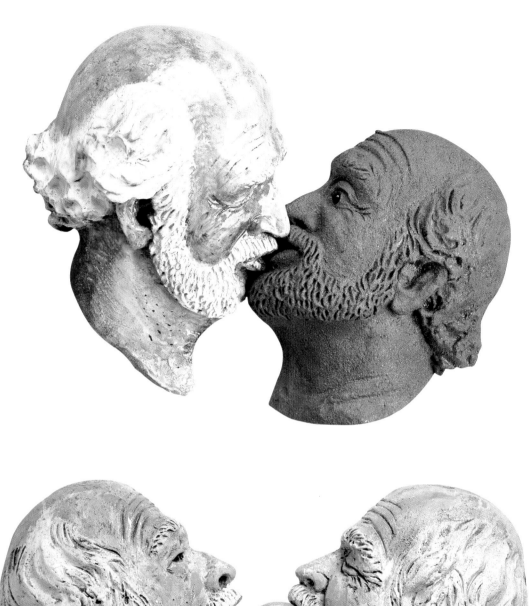

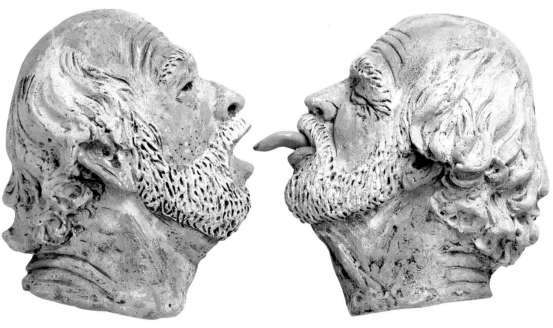

PLATE 25 (top)
Earth Angel Mine, 1991

PLATE 26
Tongue Catcher, 1992

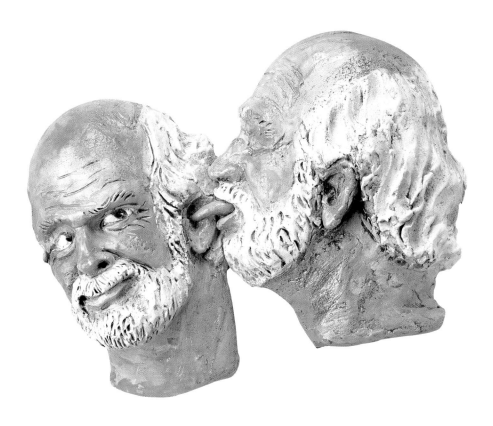

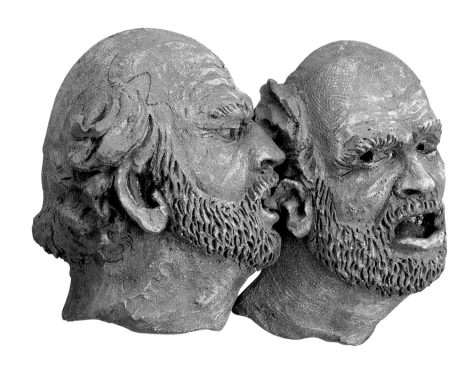

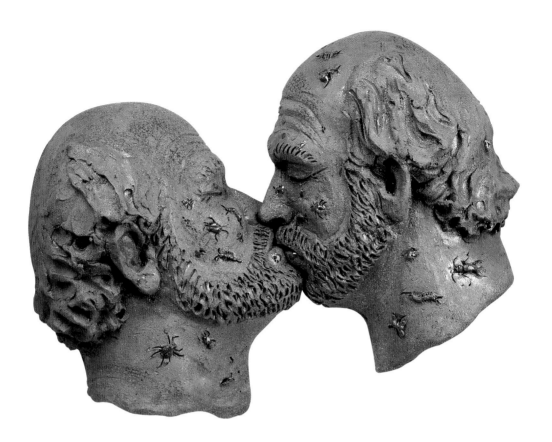

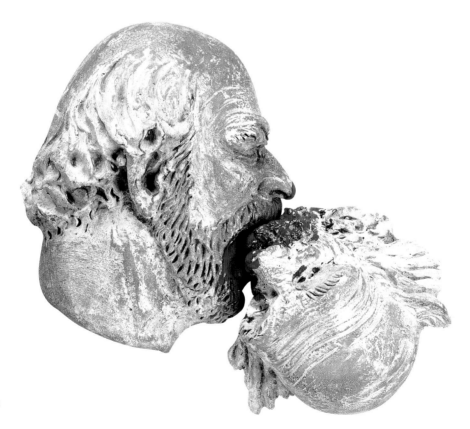

PLATE 29 (top)
Bugs, 1991

PLATE 30
Head Eater, 1991

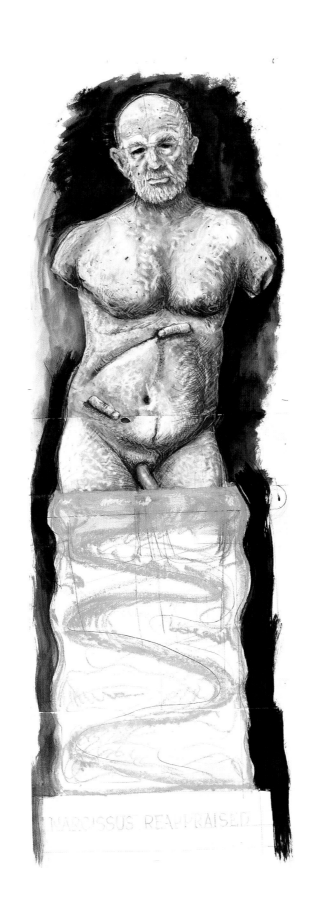

PLATE 31
Narcissus Reappraised, 1992

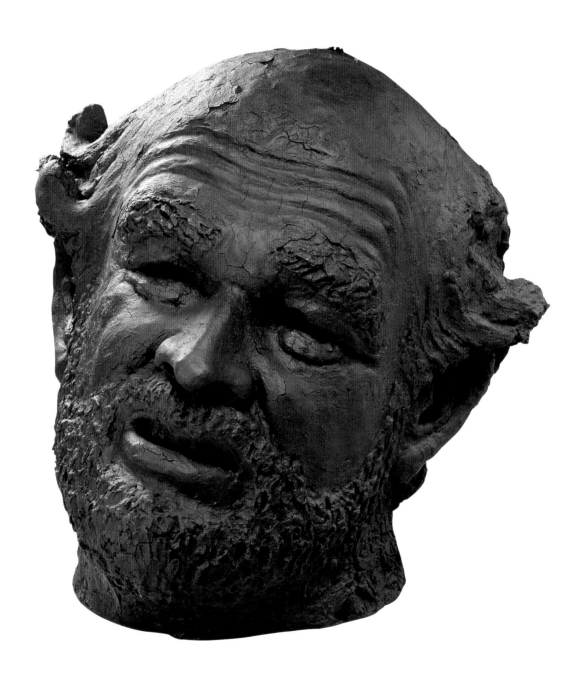

PLATE 32
No Pain, 1991

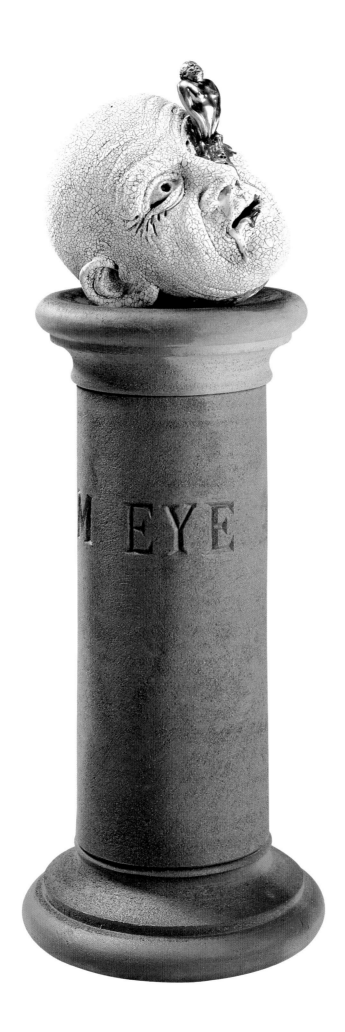

PLATE 33
From Eye Am I, 1991

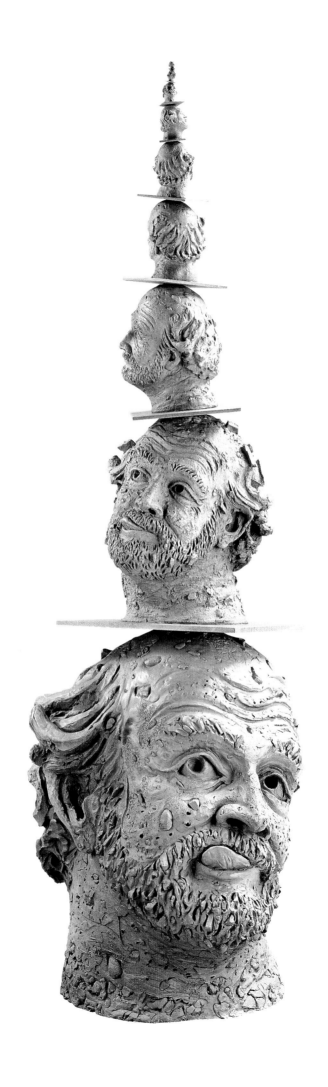

PLATE 34
Poised to Infinity, 1991

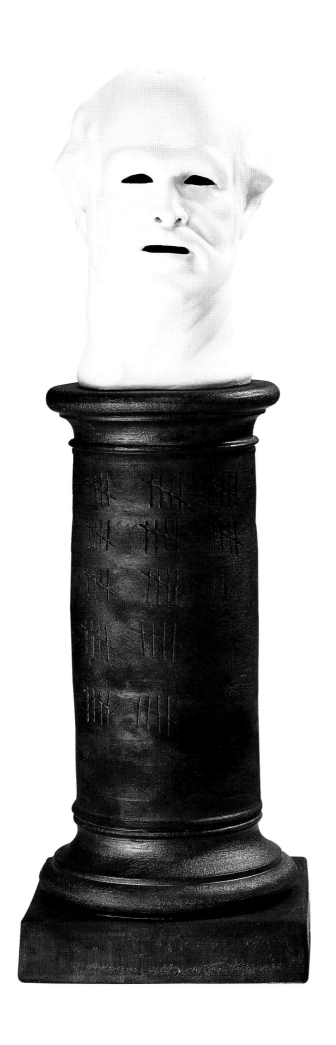

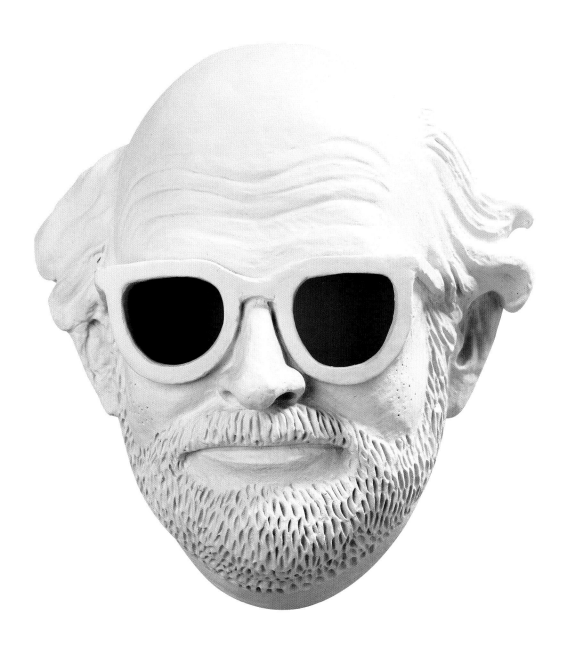

PLATE 36
White Mask, 1992

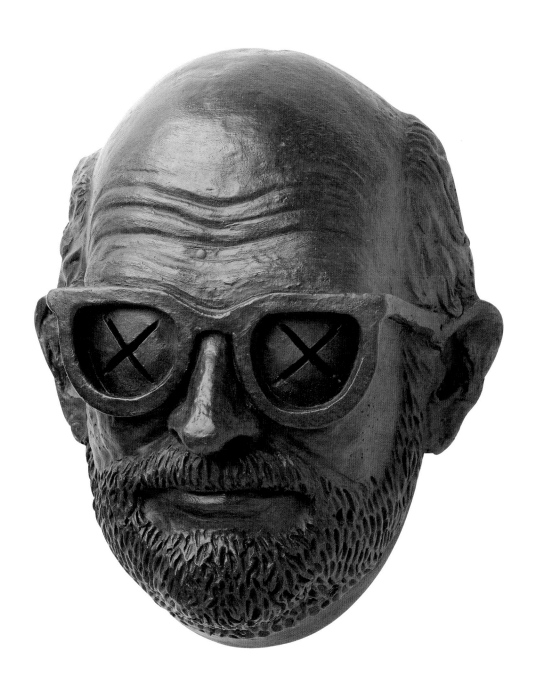

PLATE 37
Cancelled Mask, 1992

Trophy Busts

Arneson began the practice of making very small self-portrait busts in series around 1974 and would make these works intermittently throughout the rest of his career. Casting slip in the same mold, he could make several busts quickly in sequence, spending no more than a day working on any one piece. The brittleness and responsiveness of the clay would change depending on the amount of time it was left in the mold: the longer it was left, the more brittle it would become. For the trophy busts Arneson never made working drawings. Rather, their small scale allowed him to work directly with the clay, to try out and test effects, both taking away and adding clay to the initial molded form, much as if he were making quick drawings in a sketchbook. Thus the immediacy and inventiveness of these sculptures are unique in his work, and one can see and sense his mind processes in ways that are less available in the large-scale and more finished sculptures.

Arneson often gave the trophy busts to friends or people who had assisted him, people who otherwise would not be able to have his work. No comprehensive count or record of them exists. He did, however, retain several in his studio as references for potential large-scale sculptures, one of them done in 1978 (pl. 40, left) clearly serving as the model for *Chemo 1* (pls. 47–49), which he made in 1992. **GG**

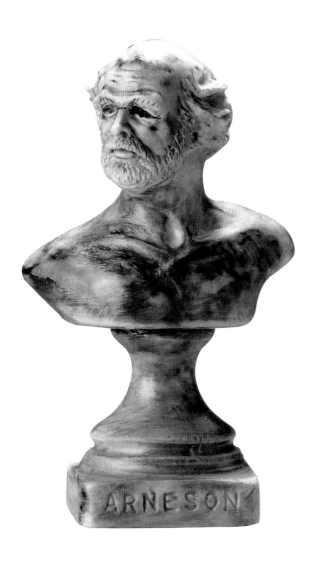
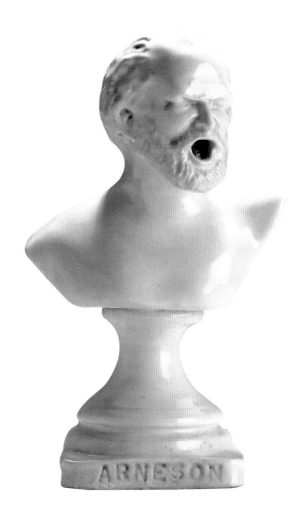

PLATE 38 (left)
Trophy Bust, 1978

PLATE 39
Trophy Bust, 1978

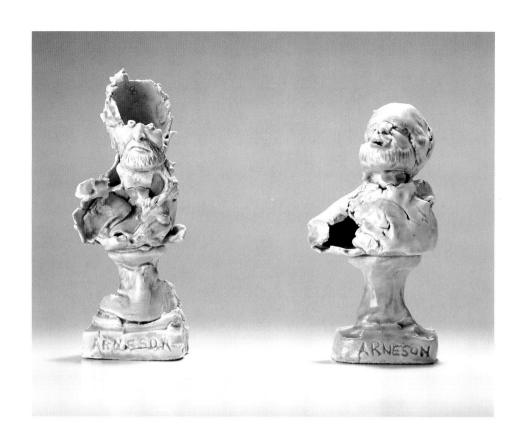

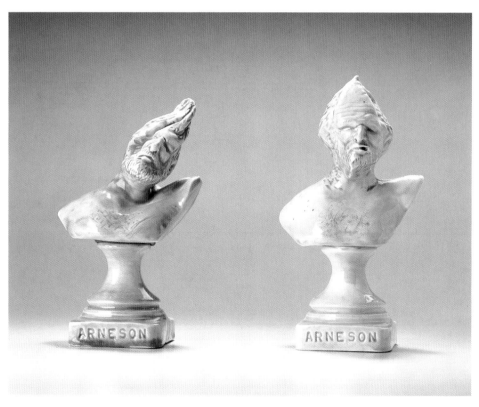

PLATE 40 (top)
Trophy Busts, 1978

PLATE 41
Trophy Busts, 1978

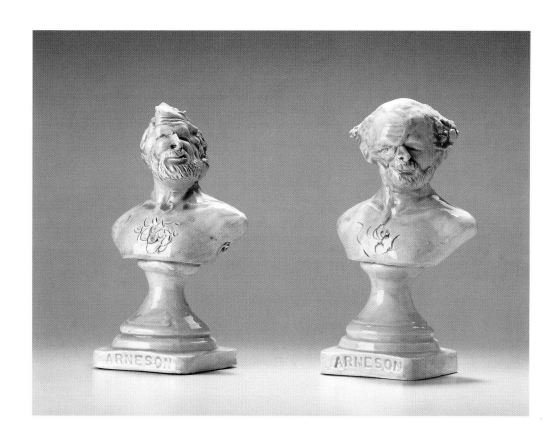

PLATE 42
Trophy Busts, 1978

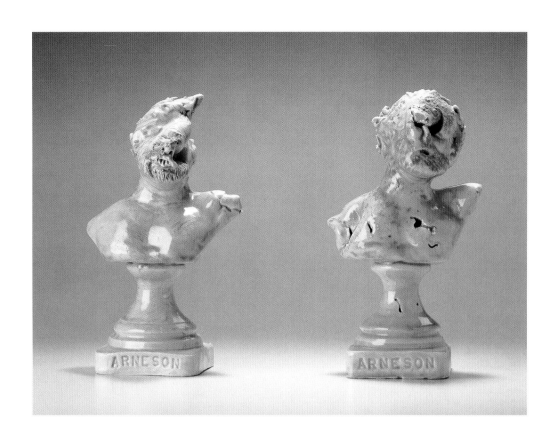

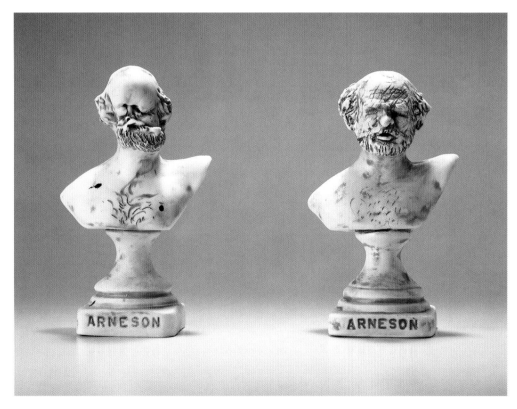

PLATE 43 (top)
Trophy Busts, 1979

PLATE 44
Trophy Bust, 1983 (left)
Trophy Bust, 1984 (right)

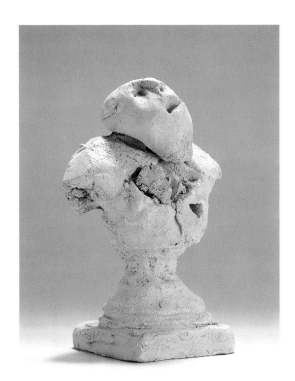

PLATE 45
Maquette for "Chemo 2," 1992

Chemo 1 and Chemo 2

These sculptures are among the last two self-portraits Arneson completed before his death from cancer in 1992. Both figures depict a body contorted, ravaged, and eaten away. With *Chemo 1* (pls. 47–49), the body has been transformed into a bony, shell-like carapace, the head a hollow cranium with bulging eyes staring intently and alertly ahead, the expression of the mouth and face firm with perhaps a trace of a smile. With *Chemo 2* (pls. 50-52), the body is more intact, flesh remaining but ripped and pulled, and the head is arched back, pain palpable but turned inward. The first figure evokes the mind and spirit self-contained, alone and at peace, facing the abyss of eternity. The second reveals the agony of the body at death. Although these are tormented and haunting figures, they retain extraordinary dignity of both body and spirit.

In these portraits the distinction between the pedestals and the body torsos has begun to dissolve, the differences between living and inert matter to disappear. The natural terracotta coloring of the fired clay maintains the connection between earth and the body, while the frosty white and coppery green mix of glazes overruns the surface and evokes icy coldness and irradiating decay, the return of the body to primordial substances. What appear to be hand-lettered inscriptions around the pedestals, executed in fact with metal stamps, detail the names and side effects of the drugs that were prescribed for Arneson in the spring of 1992 to battle the cancer that was destroying his body. Rather than transmitting the healing properties of these drugs, however, the inscriptions vividly recount a narrative of attack and added physical suffering and debilitation. One especially senses the body as an amalgamation of internal organs and unstable fluids, in contrast to the frozen flesh of the figures.

Both figures embody echoes of Arneson's first bust, *Self-Portrait of the Artist Losing His Marbles* (pl. 1), but now drained of the quirky and dark humor of that work. *Chemo 1* was inspired directly by one of the trophy busts done in 1978 (pl. 40A); *Chemo 2* was also first rendered as a trophy bust but one done in 1992 (pl. 45), a selfconscious experiment in creating this last self-portrait.

Among the most powerful works Arneson ever created, *Chemo 1* and *Chemo 2* are the culmination of his preoccupation with self-portraiture. In them all humor has been left behind; the vulnerable and noble character of the artist is fully exposed without pretense or cover, an unflinching gaze on the self when the end is seen and known and no longer just imagined. **GG**

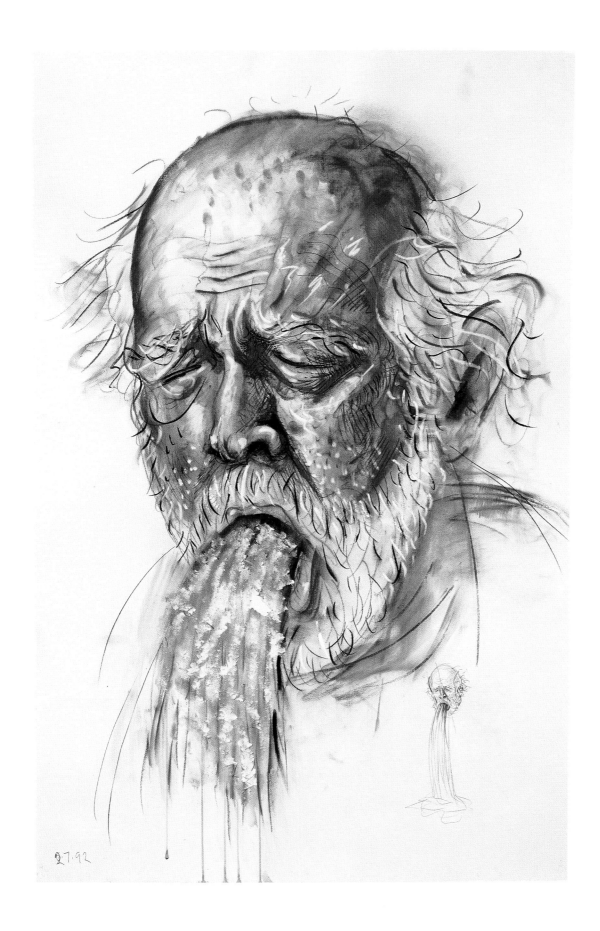

PLATE 46
Untitled, 1992

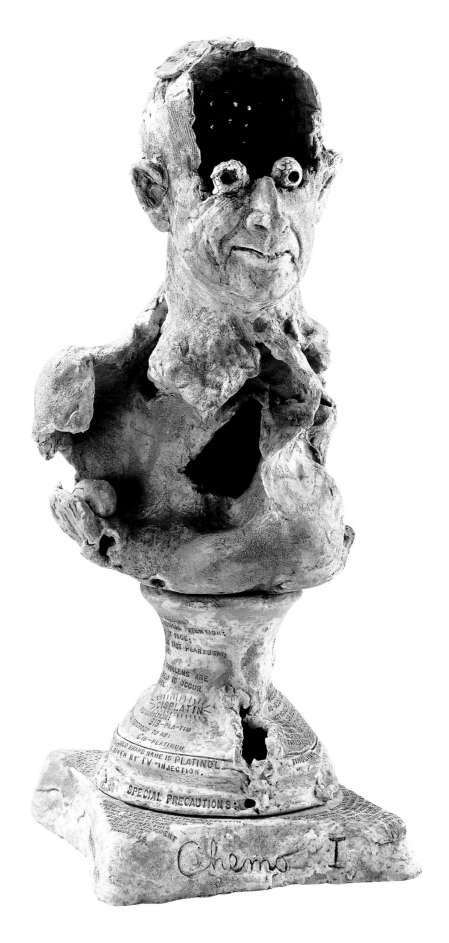

PLATE 47
Chemo I, 1992

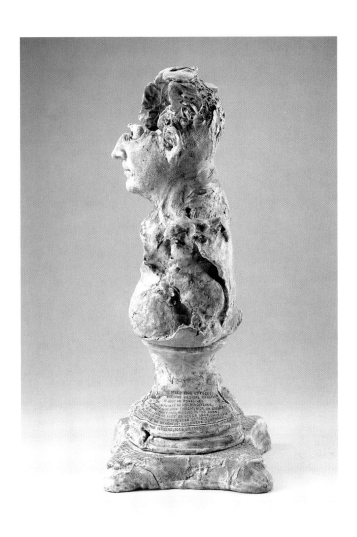

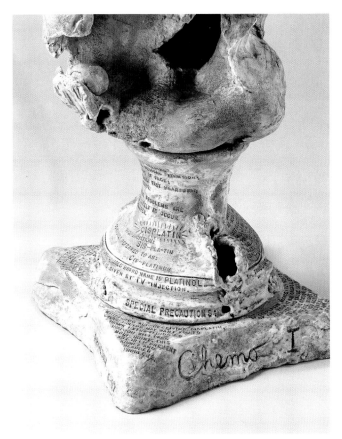

PLATE 48 (top)
Chemo I, 1992 (side view)

PLATE 49
Chemo I, 1992 (detail)

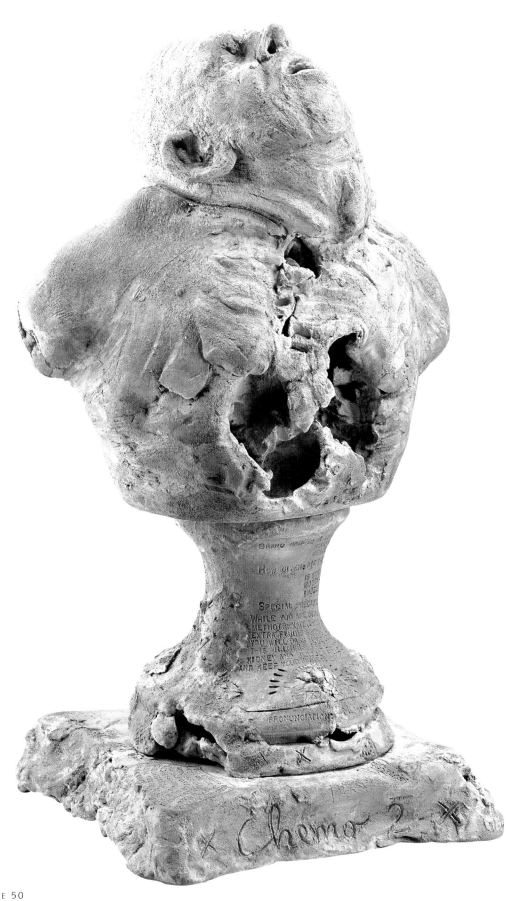

PLATE 50
Chemo 2, 1992

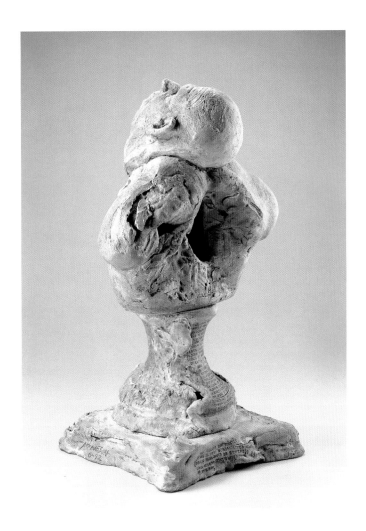

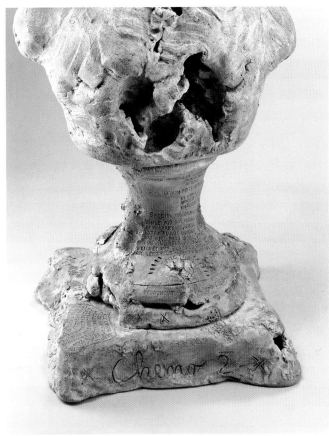

PLATE 51 (top)
Chemo 2, 1992 (rear view)

PLATE 52
Chemo 2, 1992 (detail)

Works in the Exhibition

Self-Portrait of the Artist Losing His Marbles, 1965
glazed ceramic
31 x 17 ½ x 9 ½ in. (79 x 44 x 24 cm)
Collection of the American Craft Museum,
New York. Gift of the Johnson Wax
Company, from *OBJECTS: USA*, 1977.
Donated to the American Craft Museum
by the American Craft Council, 1990
PLATE 1

Assassination of a Famous Nut Artist, 1972
glazed ceramic
30 x 22 x 13 in. (76 x 56 x 33 cm)
Collection of Ross and Paula Turk
PLATE 2

Classical Exposure, 1972
ceramic
96 x 36 x 24 in. (244 x 91 x 61 cm)
Daniel Fendrick Family Collection
PLATE 3

Man with Unnecessary Burden, 1975
glazed ceramic
40 x 26 x 26 in. (101 x 66 x 66 cm)
Buchbinder Family Collection
PLATE 4

Captain Ace, 1978
ceramic
44 x 24 x 18 ½ in. (112 x 60 x 47 cm)
Collection of the Stedelijk Museum,
Amsterdam
COVER, PLATE 5

Clown, 1978
conté crayon with collage on paper
41 ⅝ x 29 ⅞ in. (105 x 76 cm)
Purchased with funds from the Gardner
and Florence Call Cowles Foundation,
Des Moines Art Center's Permanent
Collections, 1980.4
PLATE 6

Klown, 1978
glazed ceramic
37 x 19 x 19 in. (94 x 48 x 48 cm)
Purchased with funds from the Gardner
and Florence Call Cowles Foundation,
Des Moines Art Center's Permanent
Collections, 1979.23
PLATE 7

Trophy Bust, 1978
glazed porcelain
7 ¼ x 4 ¼ x 3 in. (18.5 x 11 x 7.5 cm)
Private collection
PLATE 38

Trophy Bust, 1978
glazed porcelain
8 x 4 ½ x 3 in. (20 x 11.5 x 7.5 cm)
Private collection
PLATE 39

Trophy Bust, 1978
glazed porcelain
6 ¾ x 4 ¼ x 3 in. (17 x 11 x 7.5 cm)
Private collection
PLATE 40

Trophy Bust, 1978
glazed porcelain
7 ½ x 3 x 3 in. (19 x 7.5 x 7.5 cm)
Private collection
PLATE 40

Trophy Bust, 1978
glazed porcelain
6 ¾ x 3 ½ x 3 in. (17 x 9 x 7.5 cm)
Private collection
PLATE 41

Trophy Bust, 1978
glazed porcelain
5 x 3 x 3 in. (13 x 7.5 x 7.5 cm)
Private collection
PLATE 41

Trophy Bust, 1978
glazed porcelain
7 x 4 ¼ x 3 ¼ in. (18 x 11 x 8 cm)
Private collection
PLATE 42

Trophy Bust, 1978
glazed porcelain
7 ¼ x 4 ½ x 3 ¼ in. (18.5 x 11.5 x 8 cm)
Private collection
PLATE 42

Trophy Bust, 1978
glazed porcelain
6 ¾ x 4 x 2 ¾ in. (17 x 10 x 7 cm)
Private collection
Not pictured

Impression of the Artist as an Incorporeal Witness to the Center of the Universe, 1979
glazed ceramic
9 1/2 ft. x 9 1/2 ft. (285 x 285 cm)
Estate of Robert Arneson. Courtesy
of the George Adams Gallery and
Brian Gross Fine Art
PLATE 8

Trophy Bust, 1979
glazed porcelain
7 1/2 x 4 1/2 x 3 in. (19 x 11.5 x 7.5 cm)
Private collection
PLATE 43

Trophy Bust, 1979
glazed porcelain
7 3/4 x 4 1/4 x 3 in. (19.5 x 11 x 7.5 cm)
Private collection
PLATE 43

Drawing for "Ikarus," 1980
oil stick, crayon, and pastel on paper
29 15/16 x 52 3/4 in. (76 x 134 cm)
Collection of Harry W. and
Mary Margaret Anderson
PLATE 9

This Head Is Mine, 1981
bronze and ceramic
74 x 22 x 22 in. (188 x 122 x 122 cm)
Private collection
PLATE 10

Pour Walla, 1981–82
cast bronze and ceramic
68 x 14 x 14 in. (46 x 28 x 30 cm)
Collection of Dede and Oscar Feldman,
Bloomfield Hills, Michigan. Courtesy
of Brian Gross Fine Art, Inc.
PLATES 11 AND 12

California Artist, 1982
stoneware with glazes
68 1/4 x 27 1/2 x 20 1/4 in. (173 x 70 x 51 cm)
Collection of the San Francisco
Museum of Modern Art. Gift of the
Modern Art Council, 83.108A-B
PLATES 13 AND 16

California Artist, 1982
conté crayon and oil pastel on paper
52 x 42 in. (132 x 107 cm)
Collection of Mr. and Mrs. A. J. Krisik
PLATE 14

Eye of the Beholder, 1982
acrylic, oil pastel, and alkyd on paper
52 x 42 in. (132 x 107 cm)
Collection of Sandra Shannonhouse
PLATE 17

Study for "California Artist," 1982
mixed media on paper
54 1/2 x 41 1/4 in. (138 x 105 cm)
Collection of the San Francisco
Museum of Modern Art.
Gift of Rena Bransten, 95.110
PLATE 15

Clay I Am, It Is True, 1982–83
glazed ceramic
84 x 28 x 28 in. (213 x 71 x 71 cm)
Collection of the Birmingham Museum
of Art, Birmingham, Alabama; Museum
purchase with funds provided by Louise
and Jack McSpadden
PLATE 22

Marble X, 1983
glazed ceramic
13 x 13 x 5 1/4 in. (33 x 13 x 13 cm)
Collection of Philip Rolla,
Lugano, Switzerland
PLATE 19

Trophy Bust, 1983
glazed porcelain
7 x 4 1/4 x 2 x 2 3/4 in. (18 x 11 x 7 cm)
Private collection
PLATE 44

Trophy Bust, 1984
glazed porcelain
6 3/4 x 4 x 2 3/4 in. (17 x 10 x 7 cm)
Private collection
PLATE 44

35-Year Portrait, 1986–88
glazed ceramic
76 1/2 x 23 1/2 x 25 in. (194 x 60 x 63 cm)
Collection of Arthur J. Levin
PLATES 20 and 21

Trophy Bust, 1987
glazed porcelain
6 x 4 x 2 3/4 in. (15 x 10 x 7 cm)
Private collection
Not pictured

Press, 1988
conté crayon and charcoal on paper
48 x 31 3/4 in. (122 x 81 cm)
Private collection
PLATE 18

Self-Portrait at 57, 1988
cast paper, pour stone, and enamel
on ceramic base
28 x 14 1/2 x 14 in. (71 x 37 x 35 cm)
Estate of Robert Arneson
PLATE 23

Bugs, 1991
glazed ceramic
18 x 25 x 6 in. (46 x 63 x 15 cm)
Estate of Robert Arneson.
Courtesy of the George Adams Gallery
PLATE 29

Ear Ache, 1991
glazed ceramic
15 1/2 x 20 x 7 in. (39 x 51 x 18 cm)
Estate of Robert Arneson.
Courtesy of the John Berggruen Gallery
PLATE 28

Ear Piece, 1991
glazed ceramic
15 x 21 1/2 x 5 in. (38 x 55 x 13 cm)
Collection of Stanley and Gail Hollander
PLATE 27

Earth Angel Mine, 1991
glazed ceramic
17 x 25 x 7 in. (43 x 63 x 18 cm)
Private collection
PLATE 25

From Eye Am I, 1991
glazed ceramic with bronze
49 x 19 x 19 in. (124 x 48 x 48 cm)
Estate of Robert Arneson
PLATE 33

Head Eater, 1991
glazed ceramic
15 1/2 x 21 1/2 x 5 1/2 in. (39 x 55 x 14 cm)
Private collection
PLATE 30

No Pain, 1991
bronze (1/3)
34 x 34 x 34 in. (86 x 86 x 86 cm)
Estate of Robert Arneson.
Courtesy of the George Adams Gallery
and the John Berggruen Gallery
PLATE 32

Poised to Infinity, 1991
bronze
86 x 30 x 28 1/2 in. (218 x 76 x 72 cm)
Collection of Russ Solomon
and Elizabeth Galindo
PLATE 34

Udder Decadence, 1991
conté crayon, pencil, and mixed
media on paper
24 x 31 3/4 in. (61 x 81 cm)
Estate of Robert Arneson
PLATE 24

Cancelled Mask, 1992
bronze
12 1/2 x 11 x 5 1/4 in. (32 x 28 x 13 cm)
Private collection
PLATE 37

Chemo 1, 1992
glazed ceramic
47 x 21 x 19 in. (119 x 53 x 48 cm)
Estate of Robert Arneson
PLATES 47–49

Chemo 2, 1992
glazed ceramic
40 1/2 x 24 x 21 in. (103 x 61 x 53 cm)
Estate of Robert Arneson
PLATES 50–52

Narcissus Reappraised, 1992
oil pastel, acrylic, conté crayon,
and charcoal on paper
82 x 23 3/4 in. (208 x 60 cm)
Estate of Robert Arneson
PLATE 31

Portrait at 62 Years, 1992
ceramic
72 x 23 1/2 x 23 1/2 in. (183 x 60 x 60 cm)
Estate of Robert Arneson
PLATE 35

Tongue Catcher, 1992
glazed ceramic
16 x 29 1/2 x 5 1/2 in. (41 x 75 x 14 cm)
Estate of Robert Arneson.
Courtesy of Brian Gross Fine Art
PLATE 26

Maquette for "Chemo 2," 1992
stoneware
5 3/4 x 4 x 2 3/4 in. (14.5 x 10 x 7 cm)
Private collection
PLATE 45

Untitled, 1992
conté crayon and charcoal on paper
47 1/4 x 31 3/4 in. (120 x 81 cm)
Estate of Robert Arneson
PLATE 46

White Mask, 1992
bronze (3/3)
12 1/2 x 11 x 5 1/4 in. (120 x 81 cm)
Estate of Robert Arneson.
Courtesy of the John Natsoulas Gallery
PLATE 36

Chronology

1930

Born September 4 in Benicia, California.

1933–48

Begins drawing as a young child. Aspires to career as a professional cartoonist. Graduates from Benicia High School in 1948.

1948–51

Attends the College of Marin; graduates in January 1951; receives low grade in an introductory ceramics class.

1951–54

Awarded partial scholarship to the California College of Arts and Crafts (CCAC) in Oakland, where he enrolls in commercial-art courses. Drops out for a year to work at the Shell Refinery. Re-enrolls at CCAC and graduates with a degree in art education in 1954.

1954–57

Hired to teach a variety of art courses, including ceramics, at Menlo-Atherton High School in Atherton, California, Arneson utilizes the how-to columns in *Ceramics Monthly* and practices evenings and weekends to keep one step ahead of his students. His interest piqued, he enrolls in summer-school ceramic courses with Herbert Saunders at San Jose State University and Edith Heath at CCAC.

1955

Marries Jeanette Jensen. They have four sons during their marriage: Leif (1956), Kreg (1959), Derek (1961), and Kirk (1964).

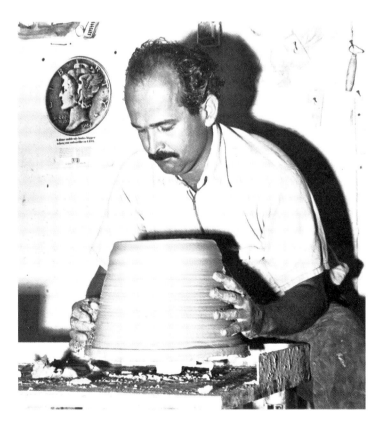

1957–58

Enters Antonio Prieto's graduate program in ceramics at Mills College, Oakland. Influenced by the work of Peter Voulkos, begins to do non-traditional sculptural ceramics. Receives M.F.A. degree from Mills. Teaches art courses at Santa Rosa Junior College for one year. Does pottery demonstrations at the California State Fair in Sacramento.

1959

Meets Peter Voulkos for the first time. Teaches art at Fremont High School for one year.

1960

Teaches design and basic crafts at Mills College for the next two years. First solo museum show at the Oakland Museum: "Ceramics and Sculpture by Robert Arneson."

Robert Arneson at a potter's wheel, ca. 1965

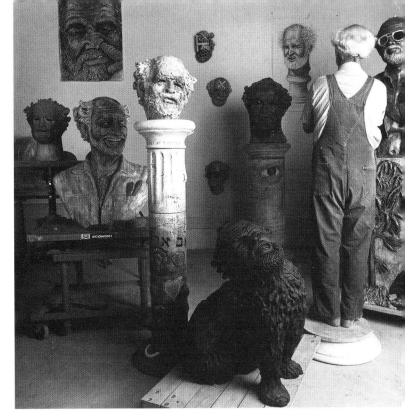

Robert Arneson with some of his artworks, 1986

1961

While demonstrating ceramics at the California State Fair ceramics booth, makes *No Deposit, No Return*, a ceramic bottle sealed with a clay bottle cap that marks his rejection of the making of traditional ceramics.

1962

"Robert Arneson: Ceramics, Drawings, and Collages" opens at San Francisco's M. H. de Young Memorial Museum. Appointed assistant professor of art and design at the University of California, Davis.

1963

Included in "California Sculpture" at the Kaiser Center Roof Garden, Oakland, California. Arneson contributes *Funk John,* a stoneware toilet, the first of a series of works based on household objects. On order of a Kaiser executive, it is removed from the show.

1964

First solo New York exhibition at the Allan Stone Gallery.

1965

Self-Portrait of the Artist Losing His Marbles, his first self-portrait bust, results when the bust cracks in the kiln and Arneson fills its fissure with marbles.

1966

Makes *Typewriter*, which is included in "Dada, Surrealism, and Their Heritage" at the Museum of Modern Art in New York in 1968. Exhibits work with his students at U.C. Davis. Begins "Alice House," a series of works based on his Davis tract home.

1967–68

First show with Hansen Gallery in San Francisco. Included in "Young California Artists" at the San Francisco Museum of Art. Inclusion of *Typewriter* in "Funk Art," at U.C. Berkeley, earns Arneson the appellation "funk artist." Appointed associate professor, U.C. Davis. A fellowship from the Institute of Creative Arts, University of California, allows him to spend the academic year painting in New York.

1969

Included in "Objects, U.S.A.," National Collection of Fine Arts, Smithsonian Institution, Washington, D.C. Johnson Wax purchases several works including *Self-Portrait of the Artist Losing His Marbles*.

1970–71

Included in the Whitney Museum of American Art's "Annual Exhibition: Contemporary American Sculpture." Takes a year off from teaching and moves temporarily from Davis to Benicia. Begins "Dirty Dish" series, ceramic visions of food-heaped plates and dirty dishes. Completes *Smorgi-Bob, the Cook,* his second self-portrait, acquired for the permanent collection of the San Francisco Museum of Art in 1972. Jeanette and Arneson divorce; it is agreed that he have custody of their four sons. *Smorgi-Bob, the Cook* is included in the major exhibition "Clayworks: 20 Americans" at the Museum of Contemporary Crafts, New York.

1971–72

Receives Artist's Fellowship Grant from the National Endowment for the Arts (NEA). Completes eighteen self-portrait busts, including *Classical Exposure* (1972), *Fragment of Western Civilization* (1972), and *Assassination of a Famous Nut Artist* (1972); they are exhibited in a sold-out show at Hansen Fuller Gallery, San Francisco.

1973

Marries sculptor Sandra Shannonhouse. Appointed full professor, U.C. Davis. Completes the technically complex self-portrait Current Event, *comprising 177 individual pieces.*

1974

"Robert Arneson" is mounted by the Museum of Contemporary Art, Chicago, and includes ceramics and drawings from 1962 to 1973. The show travels to the San Francisco Museum of Art.

1975

First exhibition with Allan Frumkin Gallery, New York and Chicago. Is diagnosed with cancer.

1976

Roger Hankins, an Arneson student, receives an NEA apprenticeship grant to work with Arneson. Arneson continues to work with assistants as a result of this first experience. Begins association with Landfall Press in Chicago. Works on monumental-scale heads. He moves permanently to Benicia.

1977

"Seven Monumental Heads," at the Allan Frumkin Gallery, exhibits Arneson's busts of friends: Roy De Forest, Allan Stone, David Gilhooly, and Peter Voulkos.

1978–80

Awarded another NEA grant. Travels in France, Belgium, Holland, and Switzerland. Begins a series of self-portraits of himself as a clown including *Klown* and *Balderdash-Dash*. George Grant becomes his studio assistant, a relationship that continues until Arneson's death. Works on bust series, "Heroes and Other Strange Types," based on seminal figures in modern art—Van Gogh, Picasso, Francis Bacon, Phillip Guston, and Marcel Duchamp—which are exhibited at the Allan Frumkin Gallery, New York, in a 1979 solo show. Moore College Art Gallery, Philadelphia, mounts the first East Coast in-depth exhibition of his ceramic and drawing self-portraiture, "Robert Arneson: Self-Portraits" (1979). Included in "Whitney Biennial" (1979), Whitney Museum of American Art, New York. "West Coast Ceramics" (1979), at the Stedelijk Museum, Amsterdam, exhibits five major works by Arneson from their collection including, *Current Event, George and Mona in the Baths of Coloma, Peter* [Voulkos], *Clown* (1977), and *Captain Ace*. Arneson and Shannonhouse attend the opening. First show devoted almost exclusively to his drawings, "Witnesses and Suspects," held at Hansen Fuller Goldeen Gallery, San Francisco, in 1980.

1981

Commissioned to do a bust of the late San Francisco Mayor George Moscone, assassinated in 1978, to be installed in the new Moscone Center in San Francisco. Included in the Whitney Museum survey of the clay sculpture movement, "Ceramic Sculpture: Six Artists," co-organized by the San Francisco Museum of Modern Art. Arneson responds to *New York Times* art critic Hilton Kramer's criticism of his contribution with the sculpture *California Artist.* Arneson's Moscone bust, *Portrait of George,* is installed at Moscone Center on November 29. On December 2 the work is unveiled, but its graffiti-covered pedestal remains covered. Displayed to the press, the outcry over the pedestal's inscriptions results in the bust's removal from Moscone Center.

1982

Portrait of George is added to the Whitney Museum's "Ceramic Sculpture: Six Artists" exhibition when it opens in San Francisco. Arneson focuses on a series of drawings of nuclear-war images. Exhibition at Nelson Gallery, U. C. Davis, "The Alice Street Drawings, Paintings and Sculptures, 1966–67." Begins his "Nuclear" series (1982–1988). Begins the "Jackson Pollock" series, which will eventually include over eighty works.

1983

Works shown in "Controversial Public Art" at the Milwaukee Art Museum, Wisconsin, and "Robert Arneson: Drawings," held at the Crocker Art Museum, Sacramento.

Robert Arneson, 1978

1985

Awarded Honorary Doctor of Fine Arts, Rhode Island School of Design.

1986

Birth of Tenaya, Shannonhouse and Arneson's daughter. "Robert Arneson: A Retrospective" mounted by the Des Moines Art Center (travels to Hirshhorn Museum and Sculpture Garden, Washington, D.C.; Portland Art Museum, Oregon; the Oakland Museum, California).

1987

Awarded Honorary Doctor of Fine Arts, San Francisco Art Institute. The Cleveland Museum of Art, Ohio, mounts "Robert Arneson: Portrait Sculptures."

1989–90

Works on the "Black" series (sculptures, paintings, and drawings) and *Guardians of the Secret II*, his tribute to Jackson Pollock.

1991

Sarcophagus, the major work from the "Nuclear" series, purchased for the collection of the Shigaraki Museum and Cultural Park in Shigaraki, Japan. Receives an Academy-Institute Award in art from the American Academy and Institute of Arts and Letters.

1992

Dorothy Goldeen Gallery, Los Angeles, and Frumkin/Adams Gallery, New York, exhibit a series of self-portraits in the form of wall reliefs. Elected fellow, American Craft Council. Completes *Eggheads*, the last of five monumental bronze sculptures commissioned for the campus of U. C. Davis, at Walla Walla Foundry in Washington. *Chemo I* and *Chemo 2*, self-portraits that explore the impact of his chemotherapy, are completed at Arneson's Benicia studio. Dies of cancer on November 2.

1993

"Robert Arneson: The Last Works," an exhibition of bronzes and ceramic works including *Portrait at 62 Years*, is held at the John Berggruen Gallery, San Francisco. "Arneson and Politics: A Commemorative Exhibition," is organized by the M. H. de Young Memorial Museum, San Francisco.

1996

"Robert Arneson: Drawing" is held at the George Adams Gallery, New York.

Bibliography COMPILED BY SUZANNE FELD

Adrian, Dennis. "Robert Arneson's Feats of Clay." *Art in America* 62, no. 5 (September–October 1974): 80–83.

Albright, Thomas. "In Memoriam, in Storage." *Art News* 81, no. 2 (February 1982): 13–14.

———. *Art in the San Francisco Bay Area, 1945–1980.* Berkeley and Los Angeles: University of California Press, 1985.

Arneson, Robert. "Letters." *Artforum* 11, no. 4 (October 1963): 2.

———. *My Head in Ceramics.* Published by Robert Arneson, 1972.

Ballatore, Sandy. "California Clay Rush." *Art in America* 64, no. 4 (July–August 1976): 84–88.

Benezra, Neal. *Robert Arneson: A Retrosopective.* Exh. cat. Des Moines, Iowa: Des Moines Art Center, 1986.

Brown, Christopher. "Bob Arneson—from Comic Books to Self-Portraits." *Artweek* 7, no. 35 (October 16, 1976): 3.

Cameron, Dan. "Seven Types of Criticality." *Arts Magazine* 61, no. 9 (May 1987): 15–16.

Clark, Garth. *American Ceramics: 1876 to the Present.* Rev. ed. New York: Abbeville Press, 1987.

Coffelt, Beth. "Delta Bob and Captain Ace." *San Francisco Sunday Examiner and Chronicle*, April 8, 1979, *California Living*, 40–47.

———. "Arneson: Portrait/Self-Portraits." *Robert Arneson: Self-Portraits.* Exh. cat. Philadelphia: Moore College of Art, 1979.

Cummings, Paul. *Robert Arneson: Points of View.* Exh. cat. Pittsburgh: Pittsburgh Center for the Arts, 1986.

Davis, Randal. "Reconsidering Robert Arneson." *Artweek* 26, no. 5 (May 1995): 16–17.

Doubet, Ward. "Robert Arneson: Portrait of the Artist as a Popular Iconoclast." *American Ceramics* 6, no. 1 (1987): 22–31.

Fineberg, Jonathan. *Robert Arneson: War Heads and Others.* Exh. cat. New York: Allan Frumkin Gallery, 1983.

———. "Robert Arneson." In *Robert Arneson: The Last Works.* Exh. cat. San Francisco: John Berggruen Gallery, 1993.

———. *Art since 1940: Strategies of Being.* Englewood Cliffs, N.J.: Prentice-Hall, Inc., 1995.

Frankenstein, Alfred. "Of Bricks, Pop Bottles, and a Better Mousetrap." *San Francisco Sunday Examiner and Chronicle,* October 6, 1974, *This World Magazine,* 37–39.

———. "The Ceramic Sculpture of Robert Arneson: Transforming Craft into Art." *Art News* 75, no. 1 (January 1976): 48–50.

French, Christopher. "Raising the Stakes." *Artweek* 16, no. 38 (November 16, 1985): 1.

Glueck, Grace. "A Partner to His Kiln." *New York Times*, May 15, 1981, C21.

Hinson, Tom E. *Robert Arneson: Portrait Sculptures.* Exh. cat. Cleveland: The Cleveland Museum of Art, 1987.

Hopkins, Henry, et al. *California Sculpture Show.* Exh. cat. Los Angeles: Fisher Gallery, University of Southern California, 1984.

Kelly, Ken. "Robert Arneson: The Interview." *San Francisco Focus* (October 1987): 45–58.

Kramer, Hilton. "Sculpture—from Boring to Brillant." *New York Times,* May 15, 1977, sec. 2, 27.

———. "Ceramic Sculpture and the Taste of California." *New York Times,* December 20, 1981, sec. 2, 27.

Kuspit, Donald. "Arneson's Outrage." *Art in America* 73, no. 5 (May 1985): 134–39.

———. *Robert Arneson.* Exh. cat. San Francisco: Fuller Goldeen Gallery, 1985.

———. "Robert Arneson's Sense of Self: Squirming in Procrustean Place." *American Craft* 46, no. 5 (October–November 1986): 37–44, 64–68.

McCann, Cecile N. "About Arneson, Art, and Ceramics." *Artweek* 5, no. 36 (October 26, 1974): 1, 6–7.

McTwigan, Michael. *Robert Arneson: Heroes and Clowns.* Exh. cat. New York: Allan Frumkin Gallery, 1979.

———. *Robert Arneson: New Ceramic Sculpture.* Exh. cat. New York: Allan Frumkin Gallery, 1981.

Malcolm, Janet. "On and Off the Avenue: About the House," *The New Yorker* 47 (September 4, 1971): 59–60.

Marshall, Richard, and Suzanne Foley. *Ceramic Sculpture: Six Artists*. Exh. cat. New York: Whitney
 Museum of American Art, 1981.

Nordless, Lee. *Objects: U.S.A.* New York: The Viking Press, 1970, 96–98.

Paris, Harold. "Sweet Land of Funk." *Art in America* 55, no. 2 (March–April 1967): 95.

Prokopoff, Stephen, and Suzanne Foley. *Robert Arneson*. Exh. cat. Chicago: Museum of Contemporary Art,
 1974.

Santiago, Chiori. "Robert Arneson: Oakland Museum." *Art News* 86, no. 5 (May 1987): 55–56.

Slivka, Rose. "The New Ceramic Presence." *Craft Horizons* 21 (July–August 1961): 30–37.

Summer, Robert. "Arneson's Bust." *Arts and Architecture* 1, no. 3 (August 1982): 14–16.

Thompson, Walter. "Robert Arneson at Frumkin." *Art in America* 76, no. 2 (February 1988): 149.

Yau, John. "Robert Arneson." *Artforum* 25, no. 3 (November 1986): 141–42.

Zack, David. "The Ceramics of Robert Arneson." *Craft Horizon* 30 (January–February 1970): 36ff.